ORD

TOP **TOP**

MSpafford

D0883407

MICHAEL C. SPAFFORD

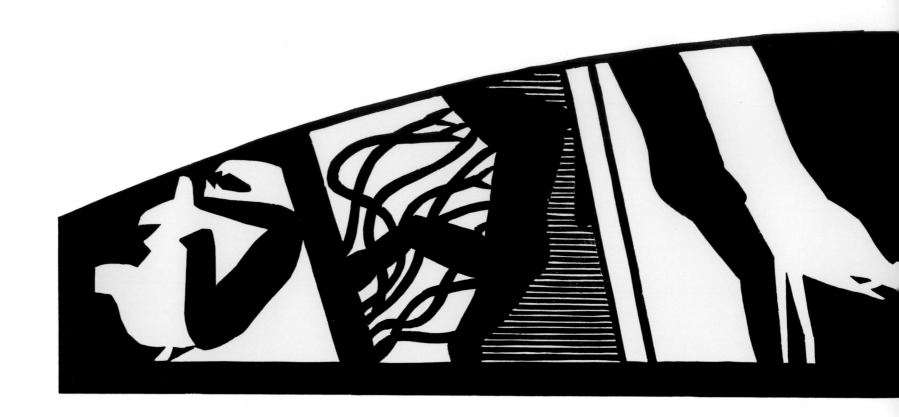

MICHAEL C. SPAFFORD

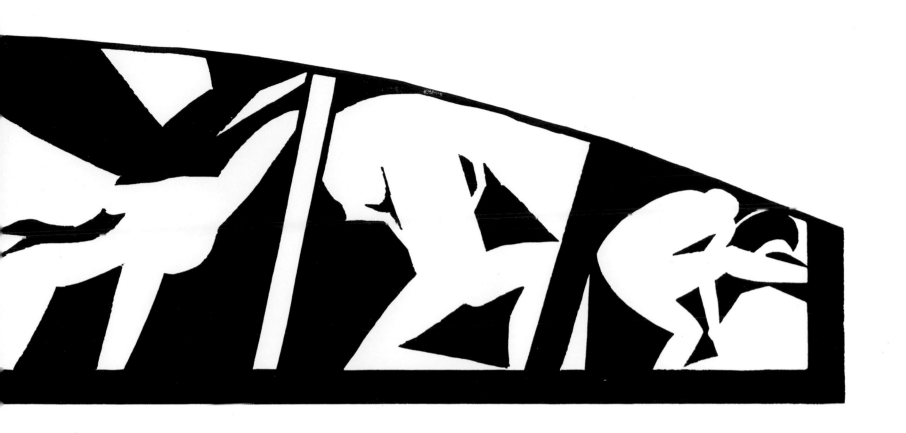

EPIC
WORKS

ESSAY BY Bruce Guenther

AN EXHIBITION IN THREE PARTS — 2018

Greg Kucera Gallery ♦ Woodside/Braseth Gallery ♦ Davidson Galleries

LUCIA | MARQUAND *Seattle*
ZOCALO STUDIOS *Seattle*

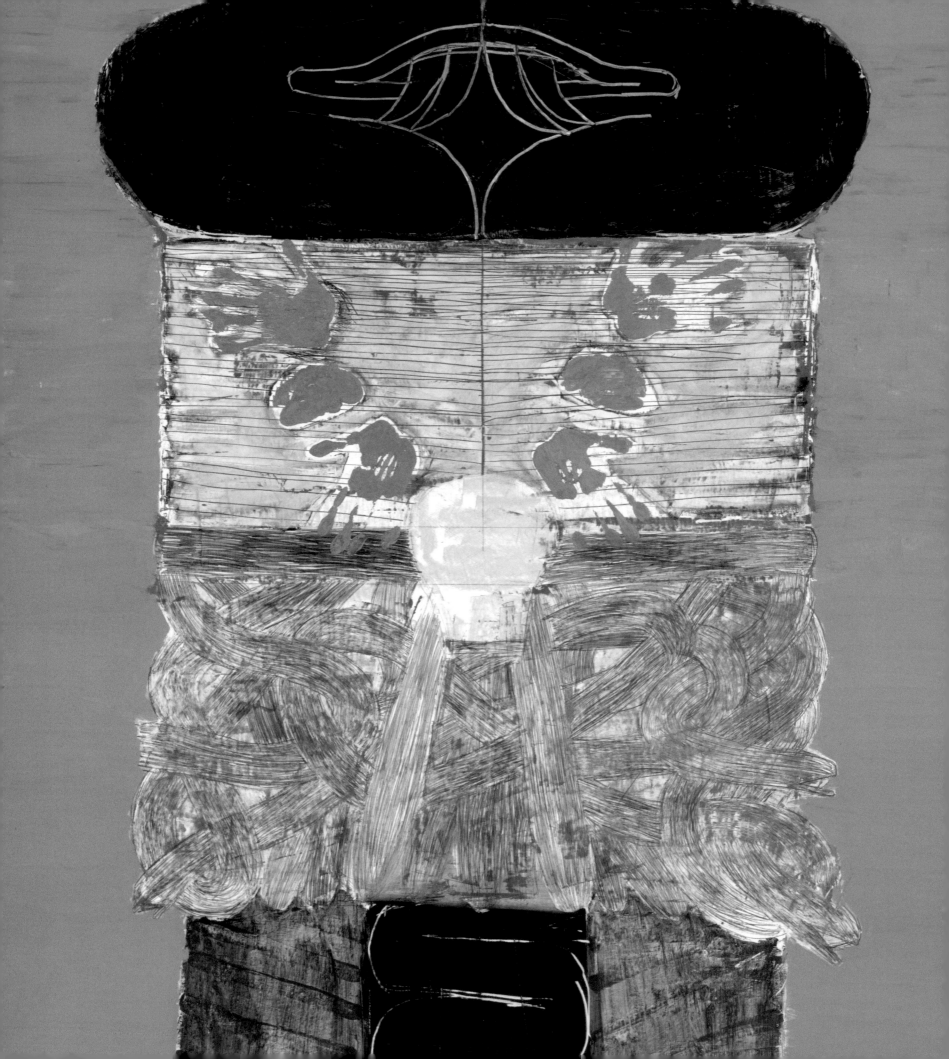

Contents

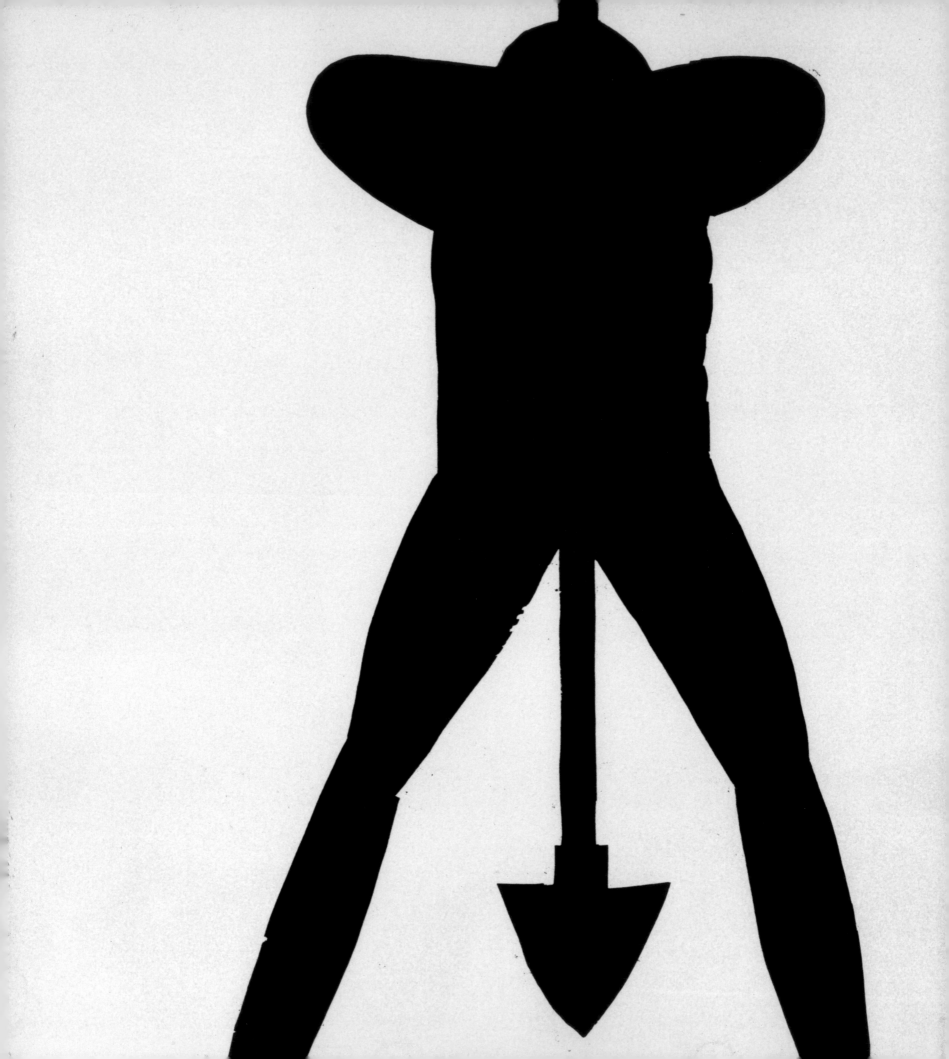

"Michael Spafford abbreviates and freely alters the stories that interest him, ignoring the convoluted and decorative. What's left are the primary passions, the excavated pressure points of human consciousness.... Myth is Spafford's catalyst. He doesn't want to shake the history off rape, romance, murder and phallus-worship, the pathological underpinnings of the heroic. In myth, he finds access to extreme situations that cannot be dismissed as contemporary aberration. He is after the pause before slaughter, the moment of cataclysmic fusion, the reverberation after. He paints pictorial currents, beyond personal grievance or moral judgment."

—REGINA HACKETT

Bellevue Arts Museum Brochure, 1990
Michael Spafford: Origins—Selected Paintings and Drawings, 1961–1990

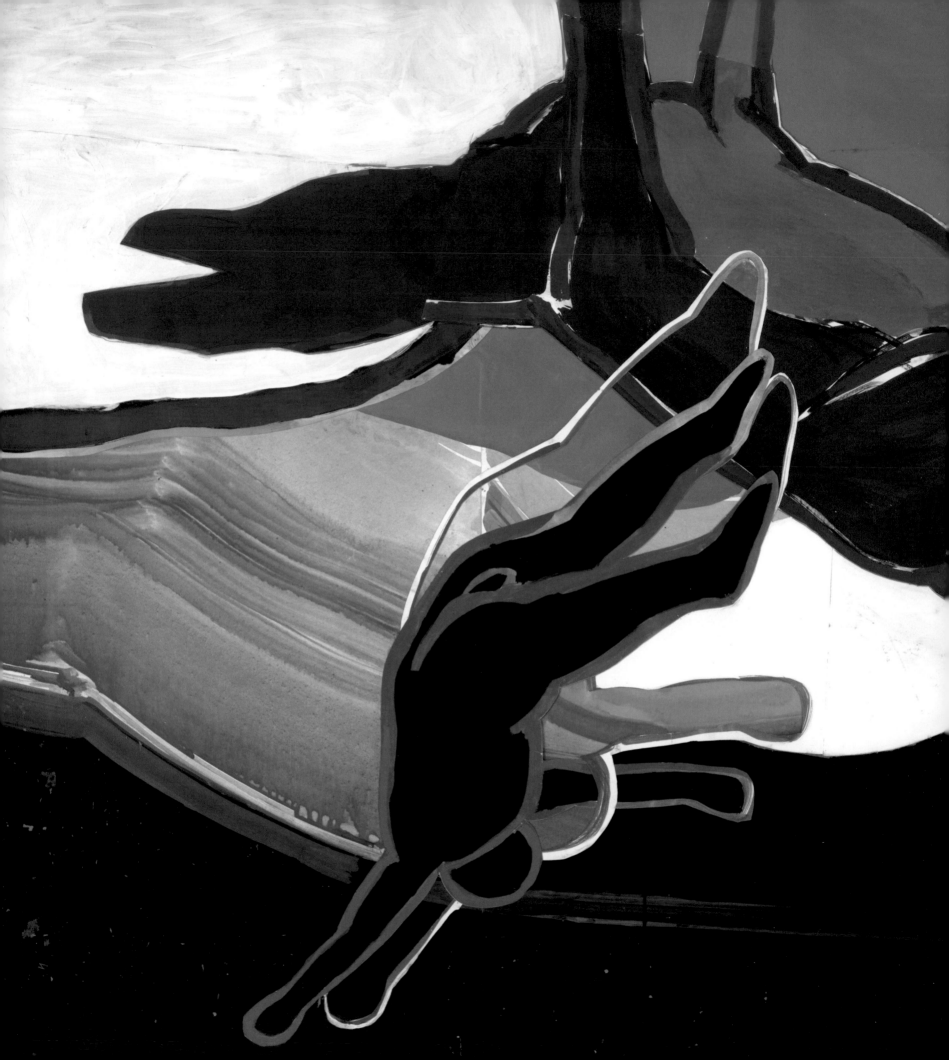

Preface

Michael C. Spafford lives upstairs. We call him Nonno. He and his wife, painter Elizabeth Sandvig, bought this rambling old house in 1965 when they moved to Seattle from Mexico City with their son (my husband, photographer Spike Mafford) and Mauda, Liz's mom. Michael taught at the University of Washington, which was within walking distance to the house, and set up a painting studio in the rough basement. Liz painted upstairs in the attic, and later down in what had been Mauda's living quarters. Which is where we live now, with our twin teenagers, Callan and Juno.

Without ever expecting to, we have lived together (quite happily) for nearly twenty years, one generation giving way to another, and the house somehow managing to accommodate all of us—which is how we finally ran out of space. Every inch was simply full to bursting, mostly with artwork. Between Mike's many fair-sized paintings and Liz's equally prolific body of work, there were hundreds of artworks scattered around the house. In the process of renovating Mike's storage racks downstairs (again), we started pulling out the multiple stacks of prints in series, the large canvases, and the huge rolls of really big drawings, not to mention the enormous diptychs and triptychs from the art storage facility. Realizing that there existed no comprehensive record of it, we decided to take it all out to our workspace, Zocalo Studios, to photograph and archive it (that was nearly three years ago).

One evening early on, we'd spread out a number of the huge canvases and were just enjoying the work. It was amazing to see a number of truly impressive pieces all in one place. We conceived of a notion: Why not try to show a group of the large works all at once? Wouldn't that be great? Thus, the Epic Works Project came into being.

While Michael has sold and shown extensively, much of the largest work had never been publicly exhibited, certainly not together. He has returned again and again to a particular story or myth, creating series over many years that contain works in different mediums and formats, though often similar compositions. While Michael never set out to illustrate Greek mythology, he instinctively chose fertile ground. Without meaning to, he has become a sort of bard, a re-teller of the old stories, who asks us to remember these origin tales and their deepest meanings. With this catalogue, we sought to pair the profound resonance of the paintings with text that informs those unfamiliar with the epic tales.

When Greg Kucera, John Braseth, and Sam Davidson stepped up to host an unprecedented multi-gallery event, it gave us the opportunity to assemble work that was still available, curated in a cohesive way. The hope is that people will visit all three galleries, and that the inclusion of the mythological descriptions will help to lend some framework to the presentation. Ed Marquand and Adrian Lucia of Lucia | Marquand have provided enormous encouragement and direction in designing an accompanying catalogue that might serve as a stand-alone document.

Over the life of this project Mike has endured our many questions, interviews, and attempts at definition with a great deal more grace than he might have. To be allowed to speak for a man who does not deal in words is humbling. To be permitted to promote the work of an artist who has no interest in promotion is an honor. To spend this time with Mike has been a gift.

LISA DUTTON SPAFFORD, *Montlake, 2018*

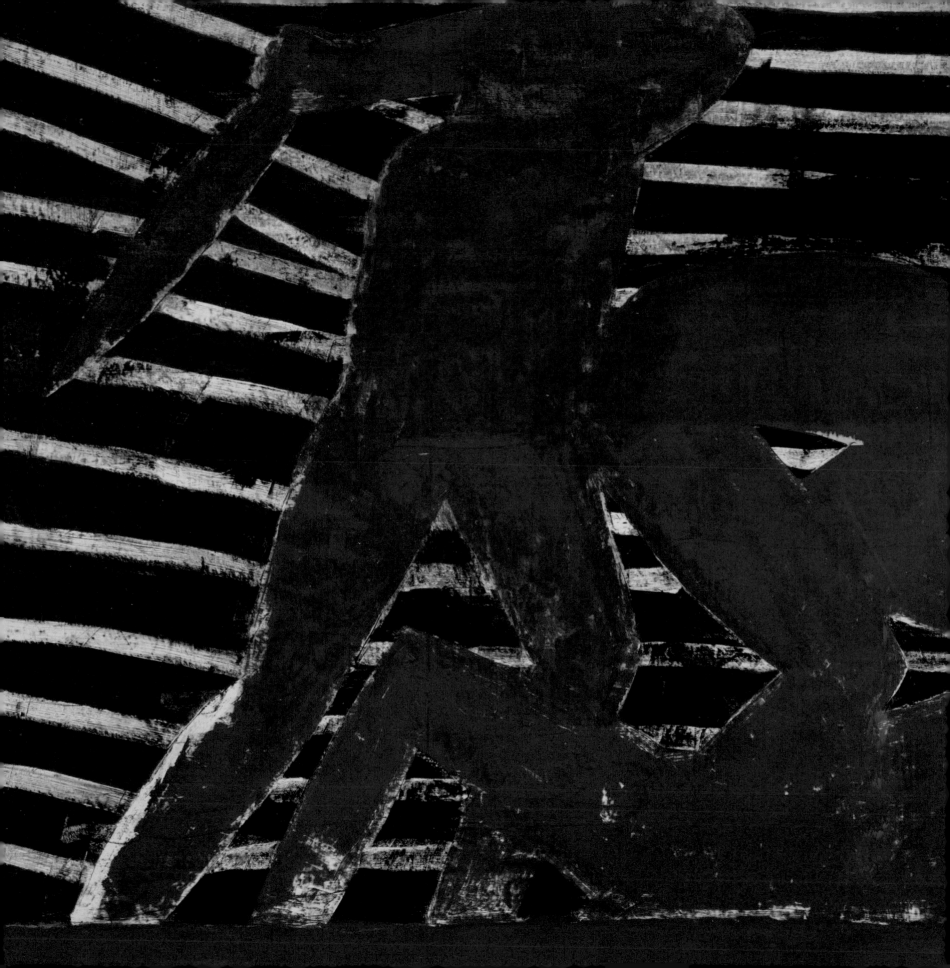

Bruce Guenther

◆

NO HEROES HERE

Michael Spafford has never abandoned abstraction nor wavered in his commitment to the promise and problems of painting. Over the course of almost sixty years as an artist, Spafford has created a body of work on canvas and paper of rare intelligence and emotional power, which has brought him national recognition and celebrity in the Pacific Northwest. He is an original and compelling artist whose paintings are both an affirmation of an ethical life and celebration of the potential of art to deeply move us.

Spafford came of age artistically in the early 1960s as the abstract painting and sculpture of the New York School struggled against obdurate American literalism, and burgeoning university art departments were just beginning the codification of abstraction as a genre that could speak only of its formal issues as *art-about-art*. It was the moment when the abandonment of historic content and big themes in the academy merged with the ongoing questions of the role of painting's public life and its relevance as a form—all of which resulted in the growing belief by both artists and the public in the "meaninglessness" of art and contemporary painting

as an activity. The marginality of art in daily life and loss of an accessible narrative would soon foster the more hermetic formalist, decorative works of post-painterly abstraction and Minimalism.

The human figure as a tool to revitalize painting against the flourishing tropes of abstraction and *painting-about-painting* had occurred to a handful of earlier artists such as Willem de Kooning (1904–1997), Lester Johnson (1919–2010), and Leon Golub (1922–2004), who were committed to direct painting and made important figuratively-based work from the 1950s on. These artists established the broad stylistic parameters of expressionist figuration and its use of human energy to produce painterly equivalents of man through physically re-enacting their characteristic forms and motions on the canvas. It was Leon Golub who would ultimately provide a model for Michael Spafford's early development as a painter, with Golub's figural references to the ancient world in the 1950s and his complex painterly attack on the canvas.

A long-held interest in mythology dating to his high school Latin classes led Spafford to step through a

metaphorical doorway to discover a world crossed between human and animal, mortals and the divine, in the refracting mirror of Greek gods and heroic struggle. He found in the epic poetry of Ovid's *Metamorphoses* and Homer's narratives the *Iliad* and *Odyssey* the figurative inspiration for a lifetime's work. Had he sat down to merely illustrate Ovid, he would not have found his imagery; instead, Spafford brought it into being through the physical act of painting itself. It is an imagery that derives its form in painting from the simultaneity of Spafford's consciousness of art, myth, and his deep feelings about the state of humanity. His mythological work and its power to move the viewer is the result of a sensibility synthesized and uncompromisingly made through the practice of painting. Images are discovered and realized through the rigor of the artist's formal reduction and the fulsomeness of paint that hovers between concept and realization, representation and abstraction. Seen against the decorative, formulaic abstraction of the last fifty years, Spafford's work is a singular case for the survival of abstract art as a meaningful form in the new millennium.

Born in California in 1935, Spafford received his formal art training at Pomona College in Claremont, California. There he had important exposure to German Expressionism and contemporary art from the then young scholar Peter Selz, who organized exhibitions of Leon Golub paintings at the college and the Pasadena Art Museum in 1956 and brought the artist to campus. José Clemente Orozco's great 1930 mural *The Triumph of Prometheus*, a fixture at Pomona, as well as the presence of painters Rico Lebrun and Hans Burkhardt in greater Los Angeles, provided Spafford with early models for the creation of a gestural abstract painting based on

Spafford in the studio, Rome, 1968

figuration and art-historical sources.

After graduating with an MA from Harvard (where he studied art history, philosophy, and the classics), Spafford and his artist wife Elizabeth Sandvig moved to Mexico City to join Sandvig's mother, who was the head librarian at the United States Embassy. Abandoning the formal study of art history to concentrate solely on painting, he was able to inexpensively set up a studio and study firsthand the masterpieces of the Mexican muralist movement by *Los Tres Grandes*—Diego Rivera, David Alfaro Siqueiros, and Orozco. Their juxtaposition of bold, often brutal, socio-political imagery with a highly cultivated formal aesthetic would become a strong influence on the development of Spafford's painting practice. It was also during this period, inspired by memories of Golub's archaic *Sphinx* and *Gigantomachy* paintings with their almost sculptural materiality, that the artist began his first investigation of Greco-Roman mythology as an intellectual framework, as a painting subject, and as a platform for discovering form through the process of working.

Spafford's three years in Mexico allowed him to work through his student influences, and establish a studio practice—as well as a driving personal vision. He painted his first independent works at this time. The *Origin Myth* series is executed in a limited monochromatic palette and features a broadly brushed naked everyman wedged into and contained by tight box-like structures suggestive of the ancient wood or stone box graves found across prehistoric Europe and the New World. Filling the canvases with this imagery, Spafford uses a full range of paint effects from opaque to transparent, solidly painted form to open dry-brushed passages that reveal the on-canvas evolution of the lifeless figures. During

his undergraduate studies, Spafford was in a traumatic, life-threatening car crash, and it is clear that the *Origin Myth* works signal not only a beginning in terms of artistic independence, but also the clearing of an emotional hurdle. It is also in Mexico that Spafford began his practice of working on extended thematic series, which would eventually spread to decades of visiting and revisiting certain motifs anew. This methodology has allowed him to develop and savor a theme, edit and rework it freshly again and again, and move it to a different medium, all the while building the cumulative emotional power of the imagery and composition with each successive interpretation.

The Mexican sojourn ended with a move to Seattle in 1963 to accept a teaching position in the University of Washington Art Department. The position and Seattle would prove to be a lasting fit for Spafford, providing him the stimulation and space to make painting the center of his life. Shortly after his arrival, two back-to-back Rome Prize Fellowships (1967–1969) took Spafford to Ovid's city where the great collections and museums of Rome gave him new perspective as an artist and the impetus to greater experimentation in his paintings. Favoring a rectangular format generally, Spafford began to cantilever the top third of a work out over the lower section, enabling images to be disengaged from the ground and hang in space—casting shadows that conflated illusion and reality, depth and flatness. In works like *Leda & The Swan* (1968), the great bird's head and neck project out and down toward the lush, twisting figure of Leda, casting a phallic shadow across her legs and pudendum. Spafford would use this device over the course of a decade or more to further animate the interaction of his figures spatially. *Perseus*

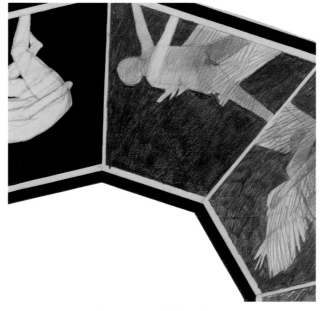

Icarus, 1968 (detail)

& Medusa (1977) has the head of Medusa as a partial cut-out painted sheet of paper suspended from the top canvas section, ostensibly held aloft by Perseus, and projecting in such a way that the Gorgon's severed head visually doubles as the victor's. The artist used a wide range of materials for the cantilevered projections—from directly cutting the canvas ground to collaged paper and suspended Plexiglas as support for his figures' lurch into real space during the period of this experimentation.

In another series of works started in Rome and based on the story of Icarus, Spafford broke completely away from a canvas support. He cut and pieced together paper isosceles trapezium mounted to plywood to create an actual spiraling ground, with each section containing the figure of Icarus first soaring, then falling downward into the spiral. Using graphite, ink, and watercolor, he deftly essentialized the form and silhouette to 'inhabit' the body as it tumbles through space. These works would eventually find form as the source material for the painted cut-steel components of Spafford's public commission for the Kingdome in Seattle, *Tumbling Figure— 5 stages* (1979; relocated 2005).

Following his experience at the American Academy in Rome, Spafford returned to Seattle with both a renewed sense of purpose as an artist and a strong studio practice. Embracing Greek mythology for the power of its imagery and its capability to address almost any contemporary issue, he forged deep into the dreams and beasts that awaited him. The complex cultural, historical, and iconographic repertoire of Ovid rushed forward, a lifetime's worth of inspiration . . . *Bellerophon and Pegasus*, *Death of Chimera*, *Europa and the Bull*, the *Minotaur*, *Laocoön and His Sons*, *The Twelve*

Labors of Hercules, Birth of Athena, Cronus Devouring His Children. Spafford found a place that fired his imagination and painterly inquiries with mythological imagery rich in powerful moral and ethical narratives through the form of physical struggle and fantastical transformations.

After selecting a myth to paint, Spafford sets to work on a loose pictorial idea, exploring images directly on a large canvas by pushing and pulling the paint around until he finds the most salient and emblematic elements of the myth for him to pursue. He does his critical thinking through the process of painting—continuously adding, rubbing out or scraping off areas to replace them. His methodology provides a way of reducing the pictorial qualities of the story to essentials—such as Perseus lifting the Gorgon's ferocious head or the Minotaur aroused by the scent of Athenian youth in the Labyrinth—that present a series of formal possibilities from which he chooses the most challenging composition to try to bring to completion. Spafford paints the myth in a radically abstracted form with little initial modeling of the figures, using only flat shape and pattern to infer their wholeness and carry forward the tale's impact. The figures are splayed out and the surface invented/reinvented through a schematic strategy built on the interplay of open and closed abstract forms, which activate the non-specific space of the canvas into an eroticized ritual ballet or battle. Spafford's constant willingness to scrape off and repaint with fresh primary gestures results in works of brilliant immediacy and emotion. When a painting is completed, he will often follow it by making upwards of ten smaller paintings or drawings on paper that are variations of the larger canvas work. In a sense, Spafford is testing or revisiting ideas discarded along the way, ideas that can become the preliminary studies that will drive the beginning of the next large painting.

Emphasizing the work's compositional structure, Spafford has often reduced color to a series of sooty blacks, compromised whites, and raw primary colors. The extreme contrast in tone serves to underscore a situation's tension and energizes the physicality of the brushstrokes. Spafford maximizes the range of viscosity and direct manipulation of pigment for expressive impact in every round. He draws, scumbles, trowels, and scrapes the paint on or off the surface with palette knife and brush in broad, sure gestures. As Cezanne once called his palette knife technique *manière couillarde*—his "ballsy manner"—Spafford too attacks the painting with an audacious vigor, repeatedly reworking it until it rings true. Ranging from thick, slab-like impasto to little more than a scraped stain, these textural effects create a sensual, physical surface that is an important aspect of the artist's painting and contribute to the power of his works.

In addition to his painting, Spafford has been an active, committed printmaker for most of his career. Favoring the physical immediacy of woodblock cutting and printing, he has created striking single images as well as monumental multi-sheet suites of prints both as an independent art form and as an extension of his painting oeuvre. Forsaking traditional woodcut textures and revealed grain, Spafford chooses to focus on the radical clarity of printed shape or abstracted figure on a pure white ground, which is printed with a maximum density of black ink to further emphasize the works physicality. Unlike his painting practice, however, the woodcuts are subject to a good deal of planning prior to execution. For the multiple image woodcut suites such as *The 12 Labors of Hercules* (1998) and *13 Ways of Looking at a Blackbird* (1986), Spafford will make a number of preliminary detailed studies in charcoal, graphite, or ink to clarify and organize the composition and the light/dark rhythms of individual prints and across the whole group. The print suites are a powerfully abstract narrative form that harkens back to the great historic series of Jacques Callot and Francisco Goya.

The artist has also incorporated woodcuts into his painting process as a tool for objectively seeing compositional structure and assessing the visual energy operating in a complex work in progress. After a painting is completed, Spafford will frequently cut a woodblock of it to further think about the theme before moving forward to the next version of the painting. Woodblock prints are the perfect medium of expression for Spafford's elegant use of solid and void to delineate form and animate space graphically.

For much of the last twenty years, Spafford has progressively reduced the compositional elements of a myth to the

simplest possible configuration of figure, ground, shape, and texture. The oil paintings and woodblocks from *The Battle of the Gods and Giants* (2002–4) broke new ground for the artist in the complexity of multi-figure compositions and radically simplified palette. Compositions are abstracted and rendered in a geometrical sequence of clear, hard forms that define anatomy and order the turmoil of war. The anonymous, abstract figures that remain take on the archetypal power of icons against the starkly featureless space of the paintings; a coda to the violence of war. Spafford evokes stasis in the face of the irrational frenzy and turmoil of battle—the hysteria of war is ordered and terror frozen. The works in this series illuminate specific violent acts which, once isolated, become atrocities, and in which naked men battle to their not-so-heroic mutual deaths. There are no heroes in Spafford's formal condensation of featureless figures and gestures which confound victim and victor as well as the blows they strike and accept. His use of stark silhouettes built of solid and void suggests in some sense the frieze-like pictorial decoration on an Athenian black-figure amphora.

In *Birth of Athena* (2016) the artist pushes the viewer into intimate proximity to the moment of Athena being birthed from Zeus' head. His use of painted drawing integrates the strong bilateral structure with fluid gesture, either actively as a drawn line or a stripe on the surface or as the subtle pentimenti of previous layers of paint now subsumed in the work's final state. The composition has a powerful balance between the extremely controlled, totemic image of Zeus' cleaved-open head from which the golden-yellow Athena emerges and the spontaneously stripped background filled with radiating lines and gestural painterly incident.

Birth of Athena, 2016 (detail)

For Spafford, art itself is a heroic endeavor—the pursuit of that which is redemptive, an act of renewal through penitence. Completely outside the specificity of photography's often-lurid record of conflicts and life, Spafford's richly physical paintings and sharply drawn prints deploy classical references to reawaken us to life with the heroic iconography of a primal struggle with death. Even as this catalogue began production, Spafford had embarked on a new series drawn on the myth of Aphrodite. He joked that it was finally time to deal with Love, but he could feel himself already caught between Botticelli and Savonarola.

The ancient myths and gods of Ovid come alive under Spafford's hand and suggest the deeper, darker regions of the modern-day hero-less conflict between light and dark, rich and poor. His works affect the viewer through their tangible physicality and their violent, even sexual, images of confrontation. The visceral shock, then, of encountering Michael Spafford's work is to realize once more our vulnerability and humanity within the numbed and numbing present.

Entangled as he is in the intellectual discourses of culture, Michael Spafford is always struggling against the facile and fashionable; he has created a unique, monumental style that is a synthesis of powerful imagery and brilliant formal invention. He deploys masterful draftsmanship and rigorous formal skills to create paintings that are psychologically penetrating and emotionally affecting. Spafford's paintings are provocative, emphatic statements that haunt memory and challenge the viewer. His vision is a timeless one, conveying moral rectitude, an affirmation of life, and a somber recognition of mortality, *poetarum veritatem.* ♦

15

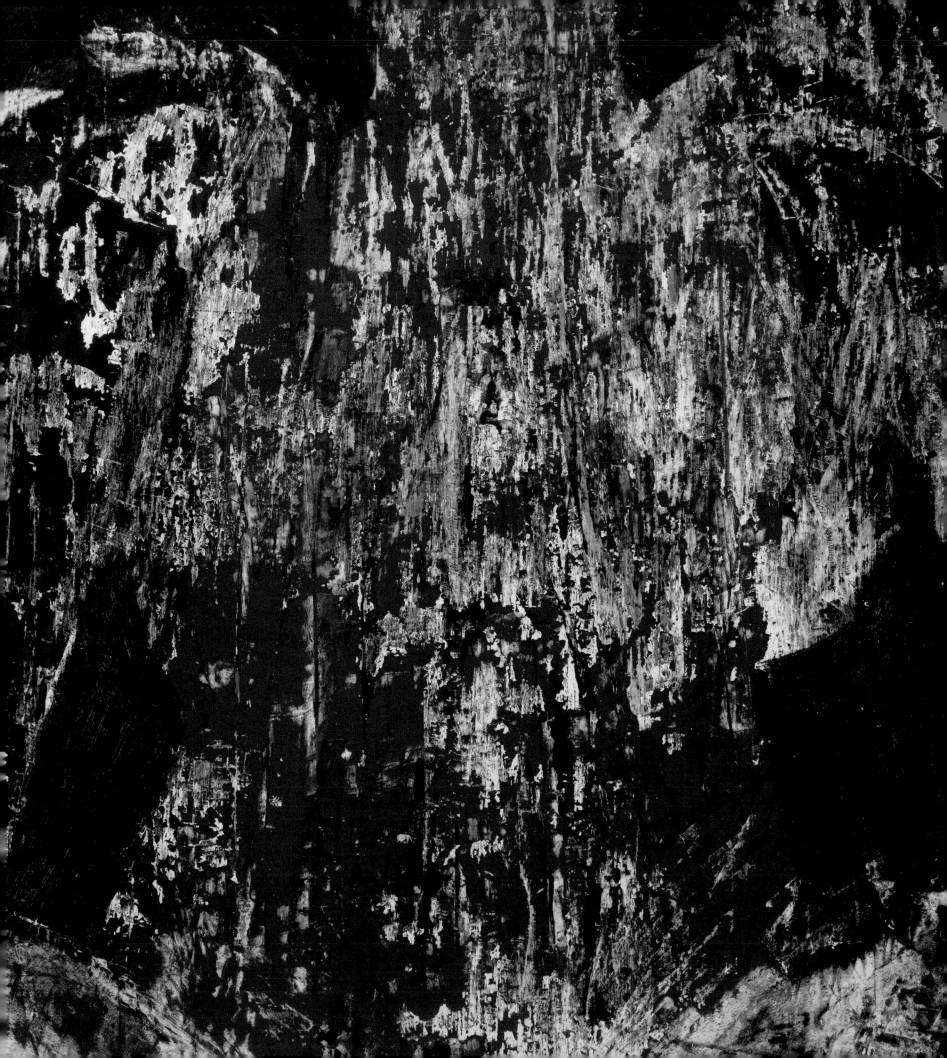

PLATES

These paintings were done at the very beginning of Spafford's career and were an investigation of something that moved beyond abstract technique and addressed elemental, iconic themes. These explorations ultimately found a focus in Greek mythology but, for a time, allowed him to express a sort of personal mythology. Spafford's hope was that each viewer would see his own narrative, feel his own struggle, within these frames

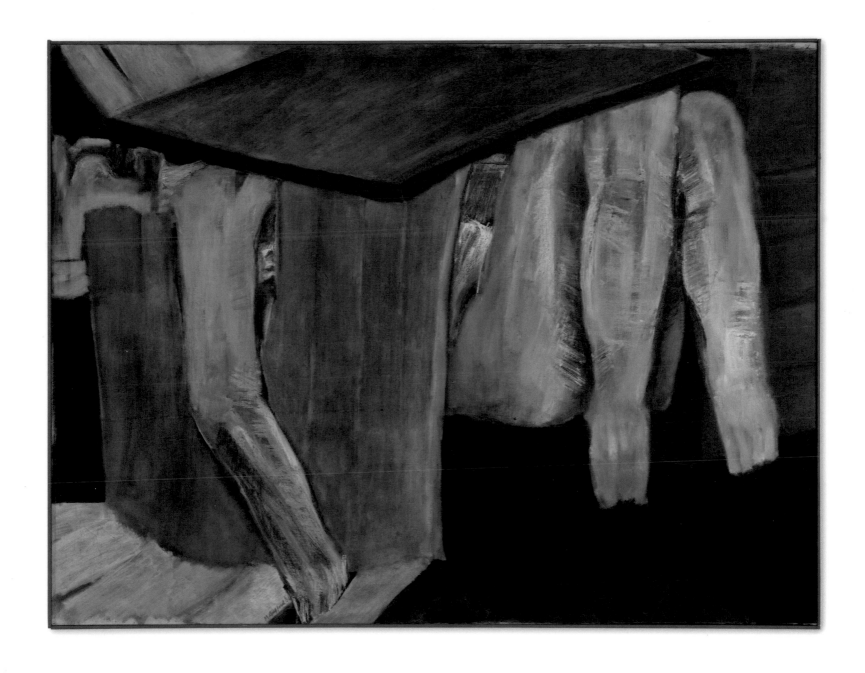

Origin Myth 9, 1961

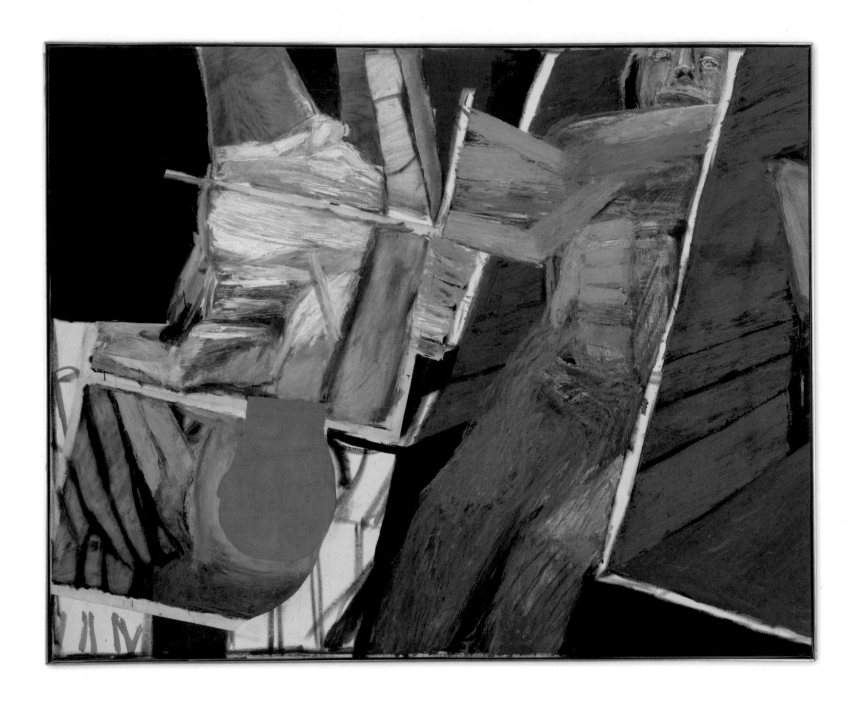

Origin Myth 15, 1964

Many ancient tales were told of the cataclysmic battle between the Olympian gods, assisted by mortals, and the Giants, a race of monstrous creatures who fought for the primal gods, the Titans. *The Gigantomachy* was part of the cycle of cosmogonic succession myths that explained the formation of the world under the primal gods, their overthrow by the Titans, and the subsequent ascendancy of the gods of Olympus. In aiding the gods, heroic men begin to rise.

Virtually all of the gods of antiquity figure in this sprawling legend, as well as great geological landmarks (at one point, the island of Sicily is flung by Athena, crushing a Giant). The war might have gone on forever, so powerful were all the forces involved, had not an oracle declared that Giants could be defeated if the gods enlisted the aid of mortal men. Hercules and Dionysus, sons of Zeus by mortal women, joined the battle and soon turned the tide; they were rewarded with immortality for their courage.

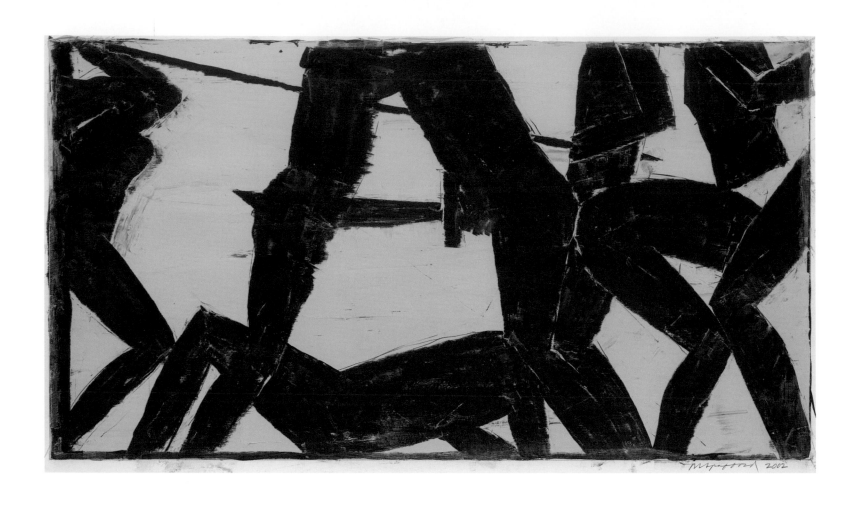

The Battle of the Gods and Giants #1, 2002

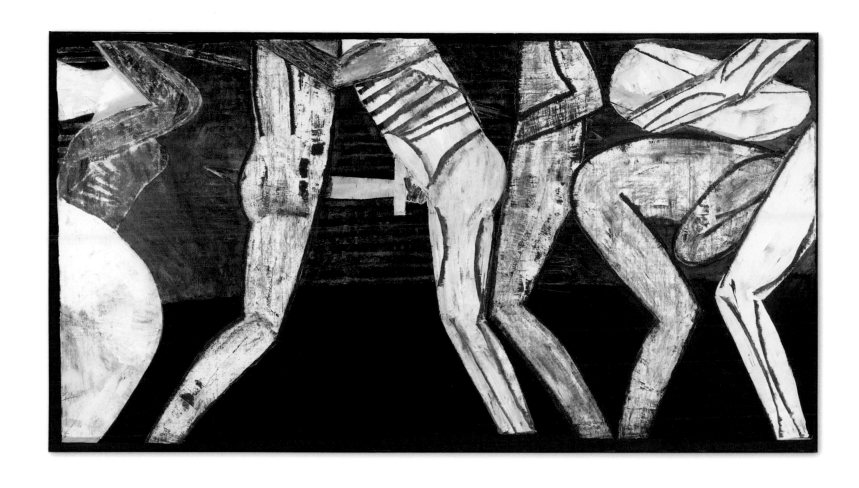

The Battle of the Gods and Giants, 2002

Zeus lusted after Metis, one of the Titans who was imbued with magical powers and known for her cunning and wisdom. While Metis tried to evade his amorous intentions (using her powers to change form many times), Zeus prevailed, though he feared the consequences. It had been prophesied that Metis, as a primal cosmogonic force, would bear extremely powerful children. Taking on the form of a frog, the god tricked Metis into turning herself into a fly and promptly swallowed her. Metis, however, had already conceived and soon Zeus began to develop a terrible pain in his head which was only relieved when Hermes took a wedge and split open his skull. Athena sprang out, a grown and powerful woman in full armor. As the favored maiden daughter of the god of heaven, she became the goddess of wisdom, protection, and victory in warfare. Many powers were ascribed to her, and she, along with Zeus and Apollo, became the Greek triumvirate of all divine authority.

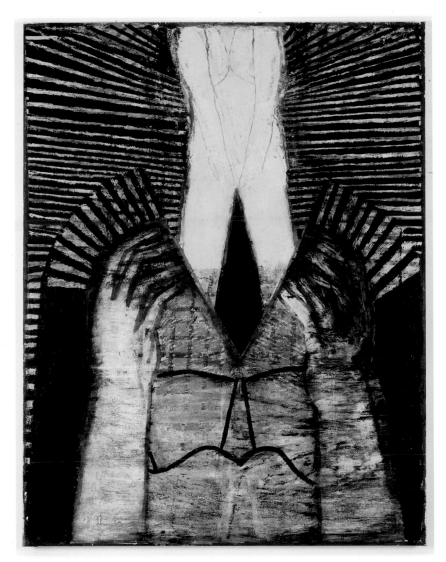

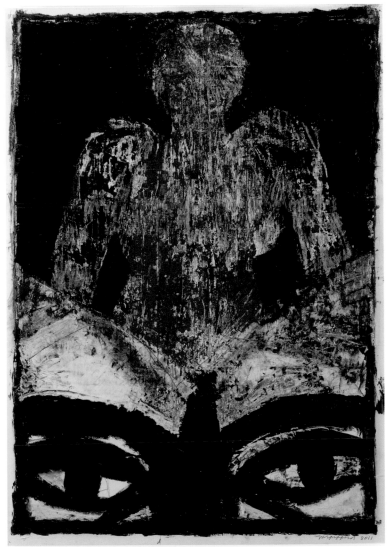

Birth of Athena, 2016

Birth of Athena #3, 2011

The legends of Bellerophon contain many elements familiar in mythological tales: youthful exile from one's homeland, jealousy and resentment from the powerful, and a long series of heroic quests in order to secure expiation and honor. Bellerophon's own tale involves tasks given to him by King Iobates of Lycia, who suspected Bellerophon of seducing his daughter. The first task was to slay the Chimera, a monster terrorizing the kingdom. With the advice of a seer and the favor of Athena, Bellerophon was able to capture the magical steed Pegasus and pursue the Chimera, who was finally killed with a spear topped with lead, which was melted by the fire in the throat of the monster. Bellerophon was emboldened by his many triumphs and his hubris grew along with his fame; he began to believe he deserved to enter the realm of the gods. Zeus was greatly angered by this presumption and sent a gadfly to sting Pegasus, who was carrying Bellerophon to Mount Olympus, causing the hero to tumble all the way back to Earth.

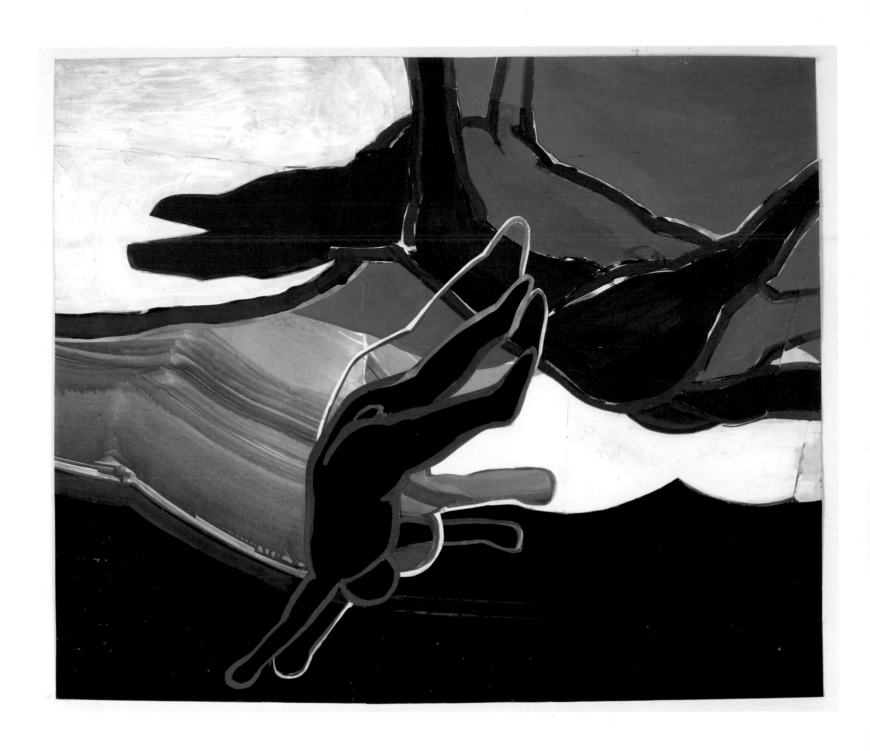

Bellerophon and Pegasus, 1970

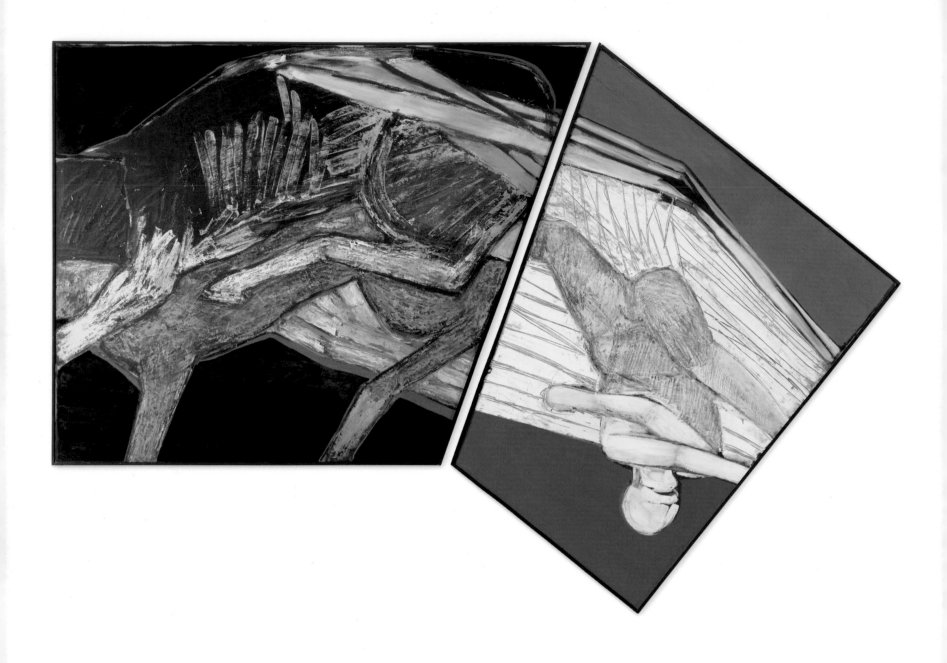

Bellerophon, 1970

Though the origin of the Chimera is much disputed, it was said to be one of many progeny of the Echidna, the "Mother of Monsters," whose other children included the Lion of Nemea, Cerberus, and the Gorgon Medusa, all of whom populate many tales of heroic deeds. Depicted with the body of a goat, the head of a lion, and the tail of a serpent, the earthbound Chimera was ultimately slain from the air by the hero Bellerophon on the back of Pegasus. A winged mythical creature, Pegasus sprang to life from the blood spattered when another hero, Perseus, decapitated the Chimera's sibling Medusa.

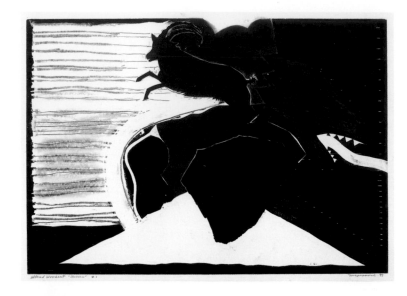 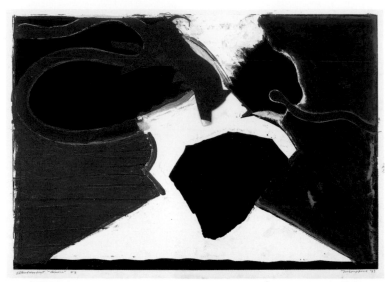

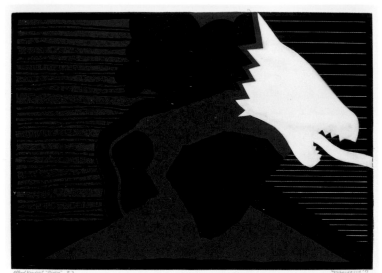 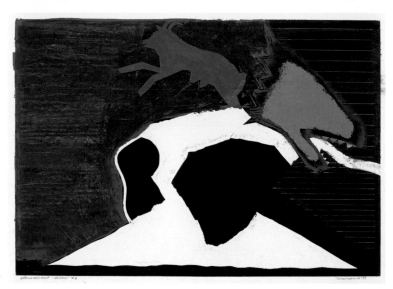

Chimera #1, 1983 *Chimera #7*, 1983

Chimera #3, 1983 *Chimera #6*, 1983

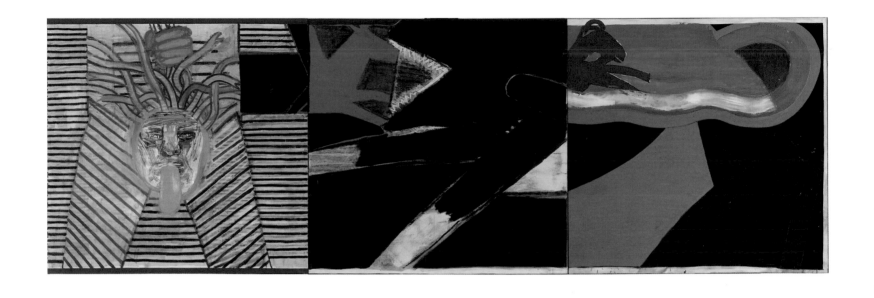

Death of Chimera, 1984

earth goddess of the Aztec religion. Also known as "mother of the gods," she gave birth to the eternally battling sibling gods who represented the moon, the stars, and the sun (Huitzilopochtli, one of the primary deities of the Aztec). Both creator and destroyer, Coatlicue was the source of life and the insatiable devourer of everything that lives. She, like many in the Aztec/Mexica pantheon, was said to feed on corpses and many sacrificial rituals were made in her honor. Her manifestation was terrifying: her head, severed in battle, was replaced by two gigantic facing serpents and her hands and feet were claws. She wore a skirt of writhing snakes and a necklace of human hands, hearts, and skulls.

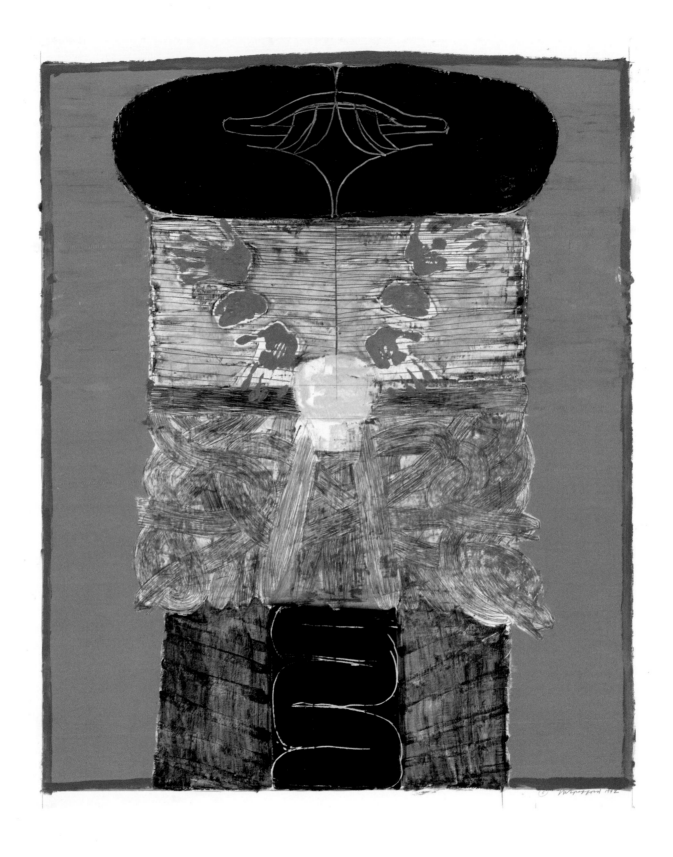

Coatlicue V, 1992

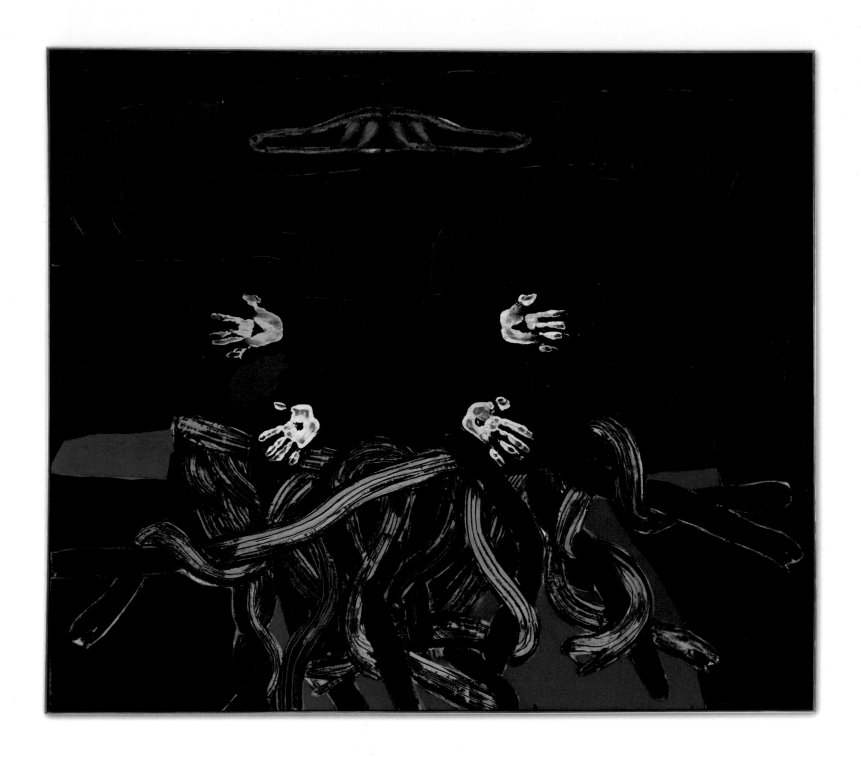

Coatlicue V, 1980

The Titan Cronus, who had castrated and banished his father, Uranus, was told that he in turn would be overthrown by one of his children. To prevent this, he decided to swallow them all: Hestia, Demeter, Hades, Poseidon, and Hera. At the birth of the last child, Zeus, his wife Rhea gave him a stone in place of the infant and hid the baby away. Ultimately Zeus gives Cronus a potion and the Titan regurgitates all of the children, setting them loose to become gods themselves. Zeus himself became ruler of Olympus, supplanting Cronus as the most powerful of beings.

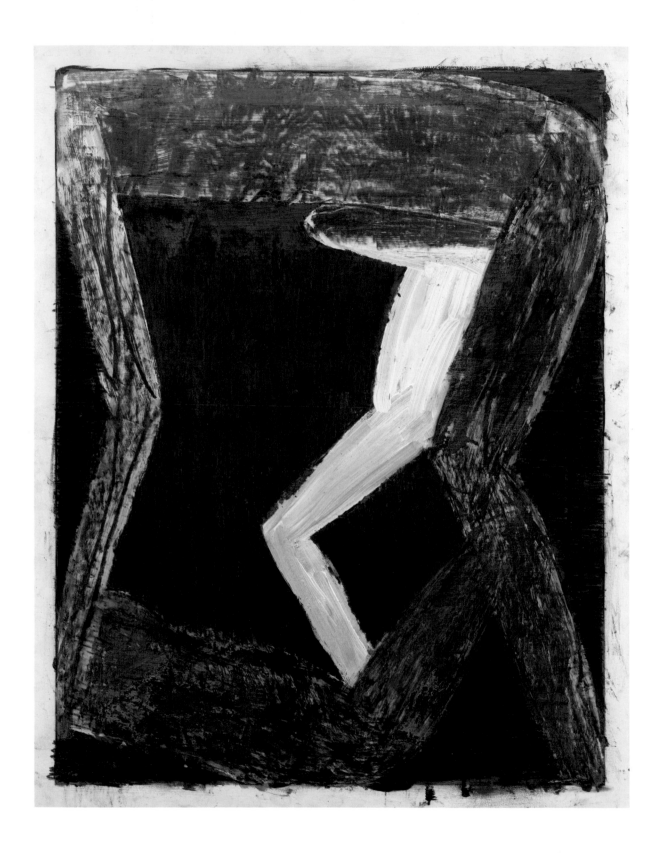

Cronus Castrating His Father, 1995

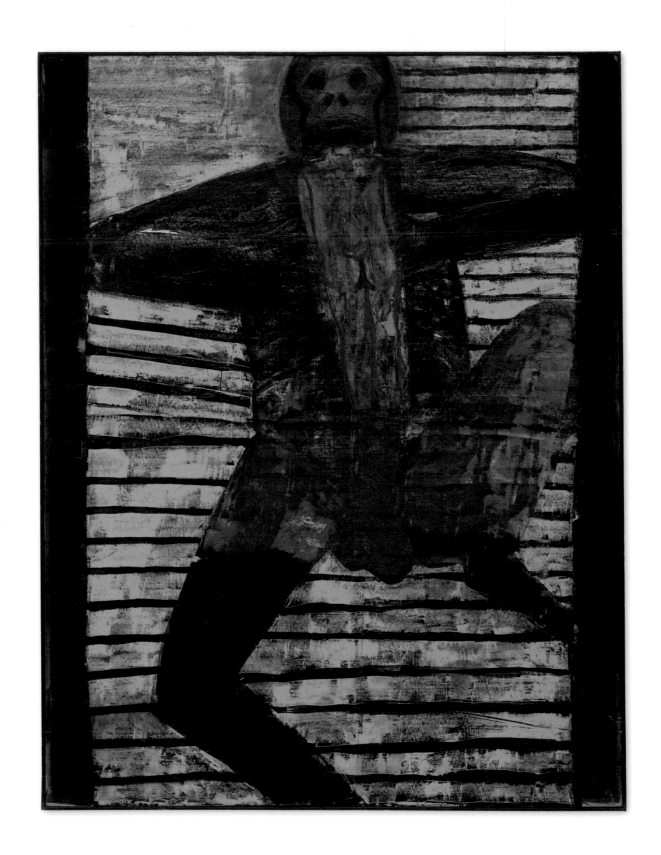

Cronus Devouring His Children #1, 1995

A myth of transformation, this tale includes one of the many unions between Zeus and a mortal woman while in the form of an animal. Though her origin was disputed, Europa was said to be a princess from Phoenicia, daughter of the king of Tyre. Enamored of her great beauty, Zeus turned into a tame white bull among her father's herds. Gathering flowers with her attendants, Europa was soon seduced, caressing his white flanks and climbing upon his back. Zeus carried her into the sea and away to Crete (a place known for its reverence of the sacred bull). There was, in Greek myth, little difference between seduction and ravishment, and "The Rape of Europa" has been a subject of poets and artists since the Romans adopted the tale of the "*Raptus*," substituting Jupiter for Zeus.

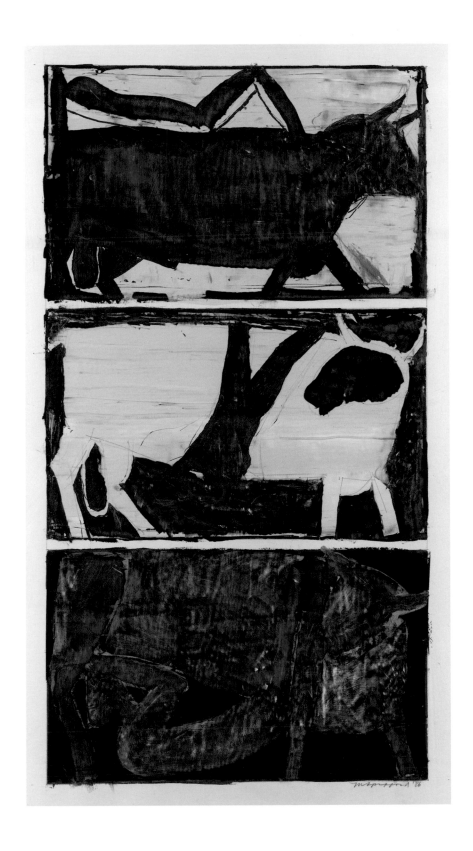

Europa and the Bull #6, 1986

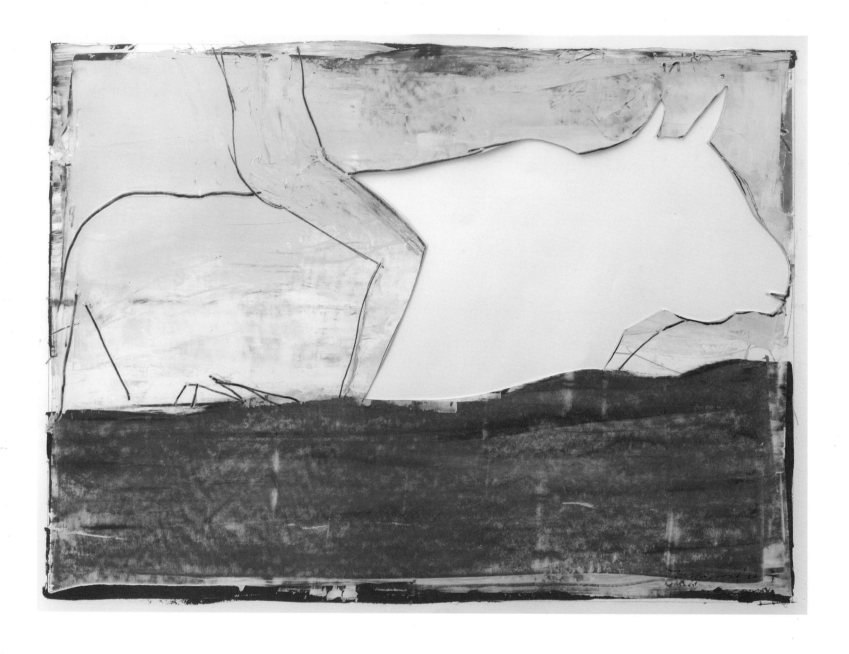

Europa and the Bull #2, 1986

The quintessential Greek mythological hero was Hercules (or Herakles). In the epics of Homer, he was the son of Zeus, son of a mortal woman. The noble man taking on an endless series of terrifying, insurmountable trials has deeply defined the Euro-American concept of heroism.

The best known tale of his exploits has become The Labors of Hercules. Zeus' wife, Hera, saw Hercules as a symbol of her husband's infidelities and often worked against him. She forced him to serve a weak king, Eurystheus, and then drove the hero mad, causing him to murder his wife and children. As penance and humiliation, he was assigned the task of completing a set of inexplicable labors such as battling a monstrous being or accomplishing an impossible task. All were successfully accomplished by Hercules through a combination of wile, bravery, and strength. Though the order and number of the Labors has varied over time, Spafford himself created an alternate labor, ending the series at one point with Confronting Death.

The Twelve Labors of Hercules as commonly done by Michael Spafford:

1 Slaying of the Nemean Lion
2 Vanquishing the nine-headed Lernaean Hydra
3 Capturing the marauding Erymanthian Boar
4 Destroying the vicious, iron-beaked Stymphalian Birds
5 Chasing down the fleet, golden-horned Ceryneian Hind
6 Cleaning the dung out of the Augean Stables
7 Subduing the Mad Bull of Crete
8 Abolishing the flesh-eating Mares of Diomedes
9 Stealing the jewel-encrusted belt from Hippolyte, the Queen of the Amazons
10 Obtaining the Cattle of Geryon
11 Crushing the immortal giant Antaeus
12 Kidnapping the three-headed hound of Hell, Cerberus, or Confronting Death

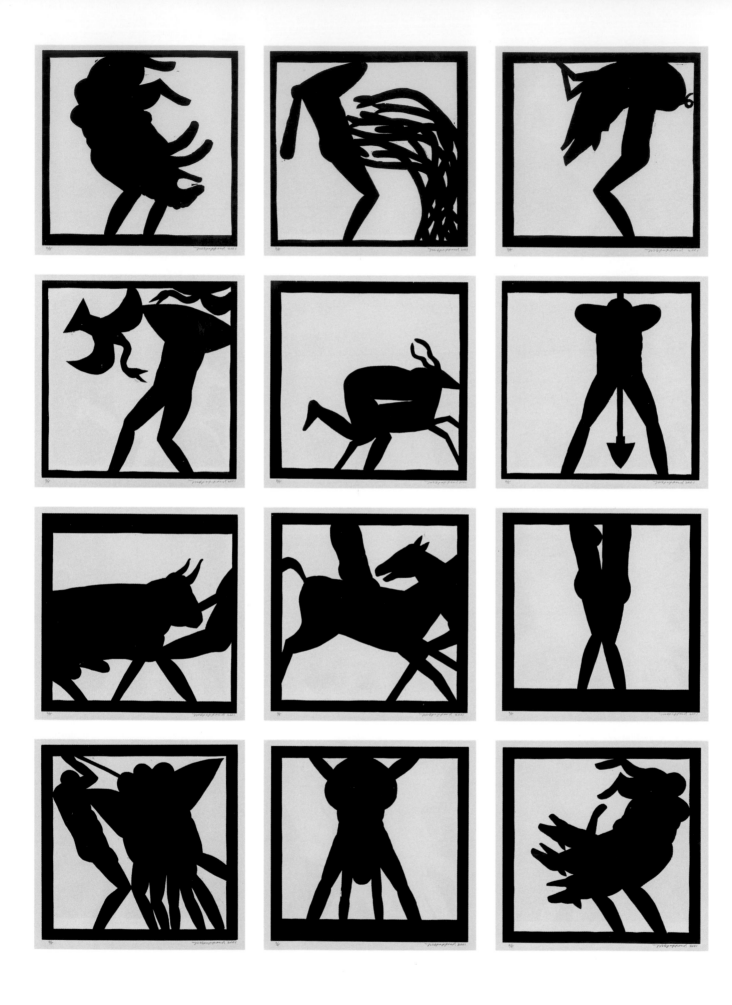

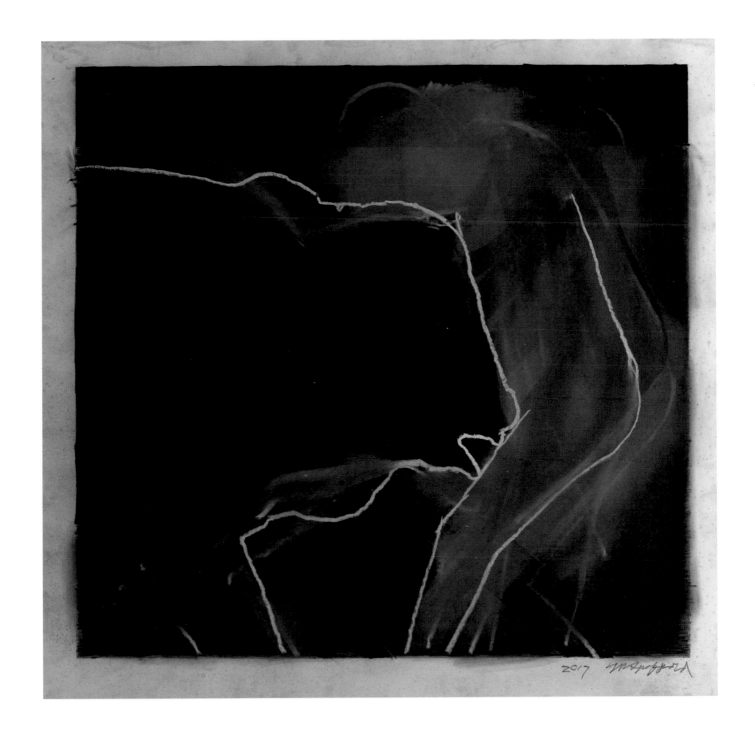

The 12 Labors of Hercules, 2001 (opposite) *Hercules with Bull*, 2017

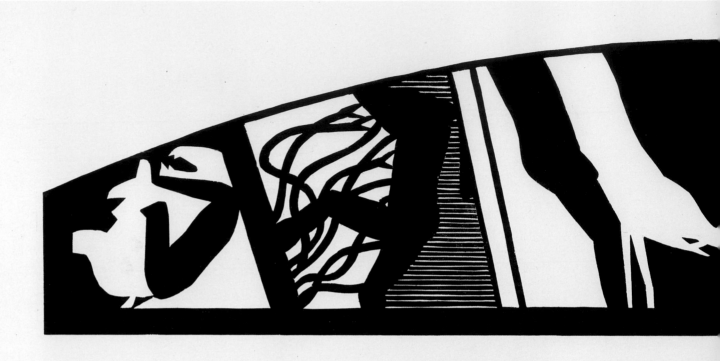

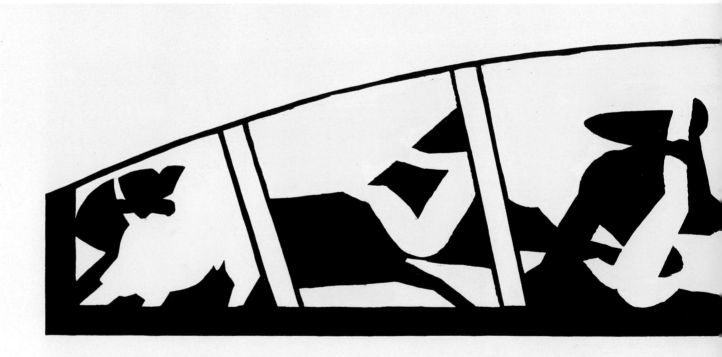

The Twelve Labors of Hercules, 1982

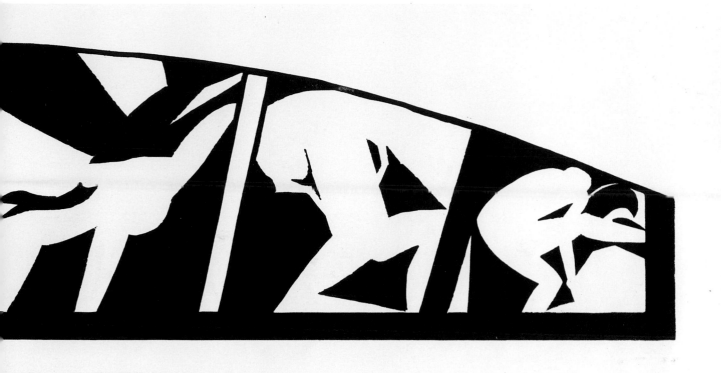

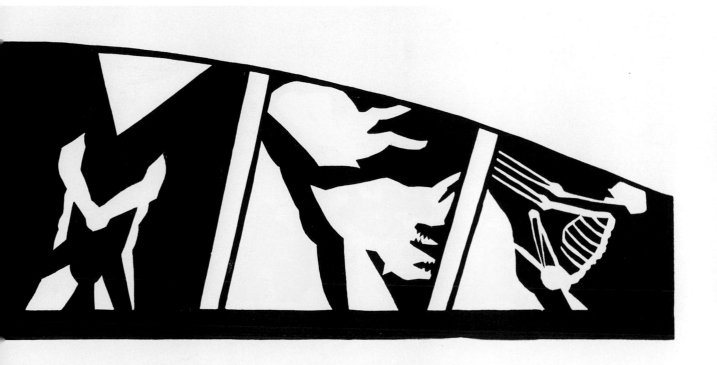

12 Labors of Hercules, 1995 (overleaf)

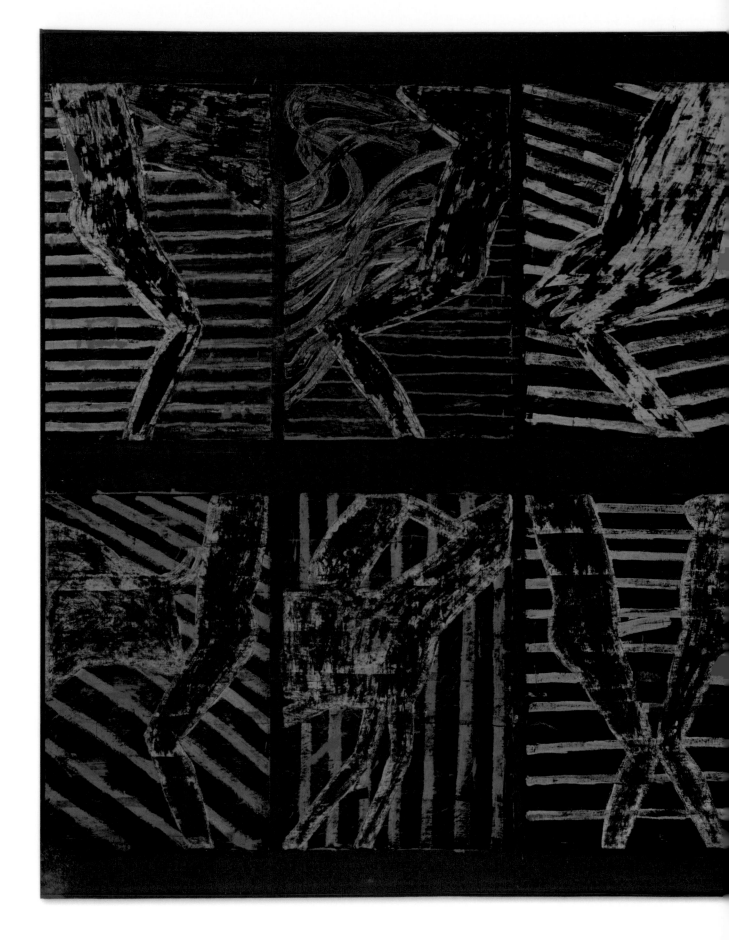

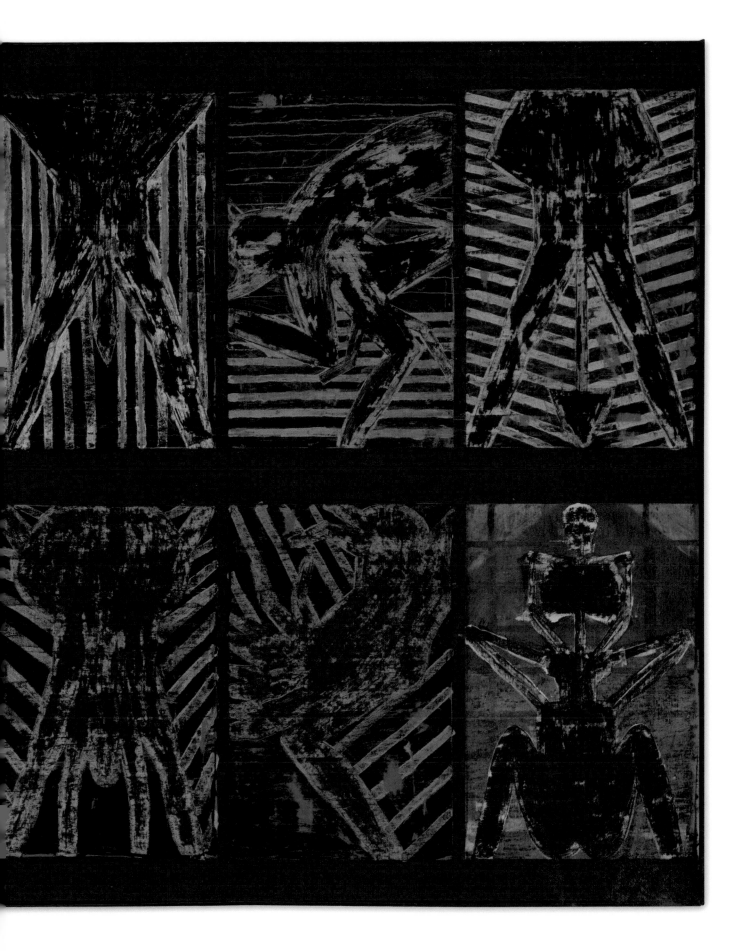

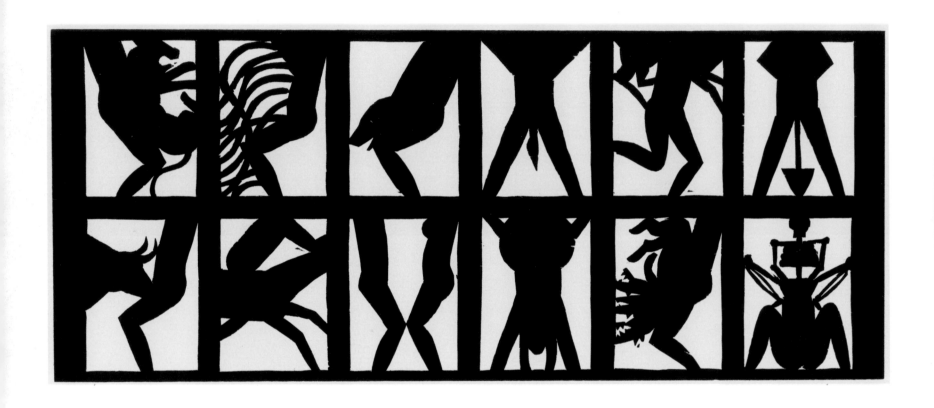

The 12 Labors of Hercules, 1998

Icarus was the son of the master craftsman Daedalus, creator of the labyrinth of the Minotaur on Crete. Imprisoned on the island by King Minos, father and son sought to escape using wings constructed of feathers and wax. Though Daedalus warned his son of complacency and hubris, Icarus, glorying in the triumph of flight, ignored this warning as he climbed ever higher. When the wax in his wings melted from the sun, he tumbled out of the sky and fell into the sea to drown.

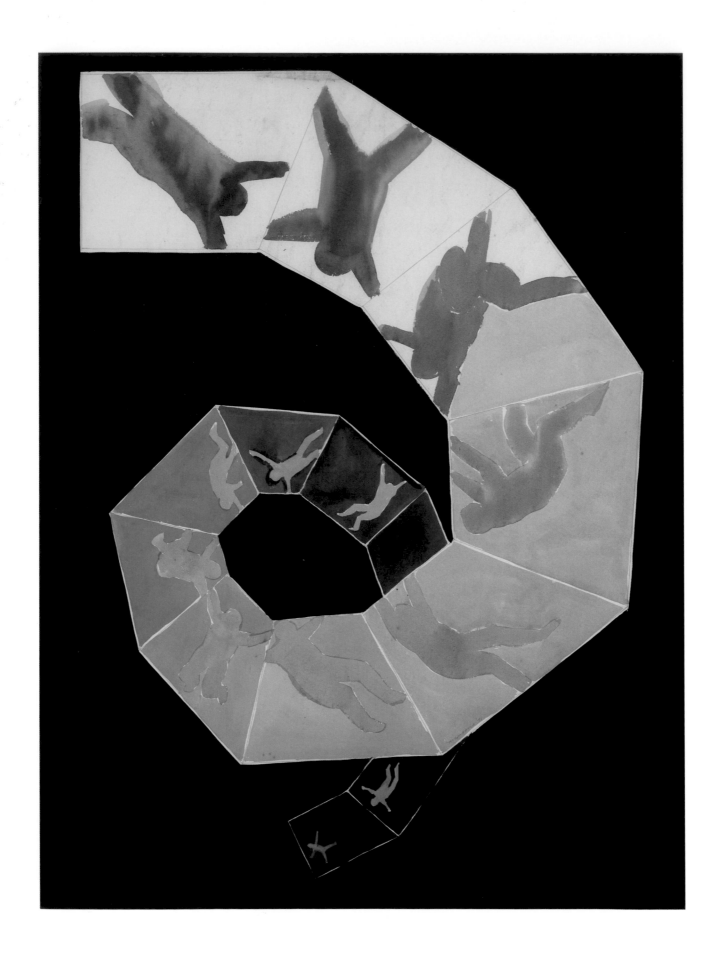

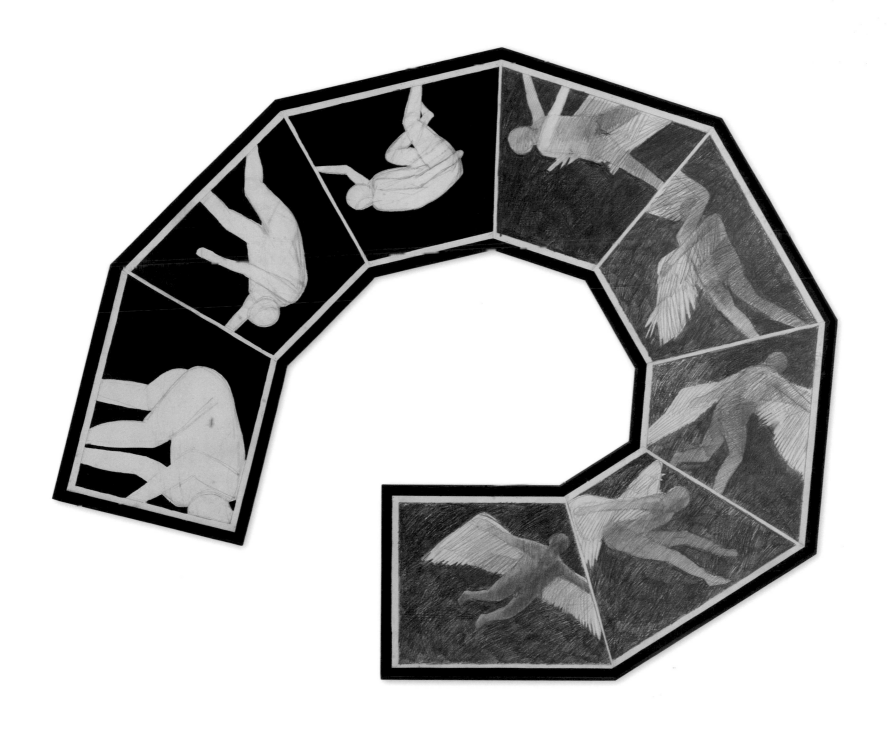

Icarus, 1971 (opposite) *Icarus*, 1968

Laocoön, a priest in the temple of Poseidon, warned the Trojans against accepting the immense wooden horse left behind by the Greeks during the Trojan War. His immortal words, "I fear the Greeks even when they bear gifts," infuriated Poseidon, who was bitterly opposed to Troy and wanted it destroyed. As Laocoön and his sons were preparing to sacrifice a bull at the altar, Poseidon decided to punish him for interfering with destiny and caused two winged serpents to emerge from the sea, wrap the priest and his sons in their coils, and crush them. The Trojans took this as a sign to ignore Laocoön's warning and immediately brought the horse inside the city walls. The Greeks, hidden within the hollow horse, crept out in the night to infiltrate and conquer the complacent Trojans.

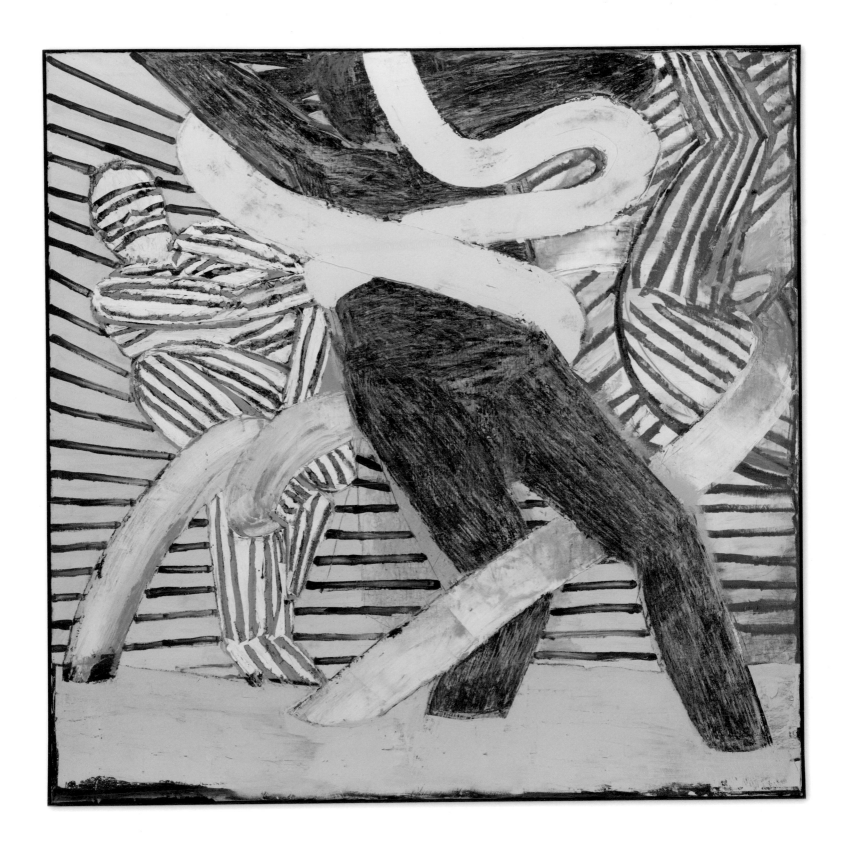

Laocoön—Sons & Serpents, 1989

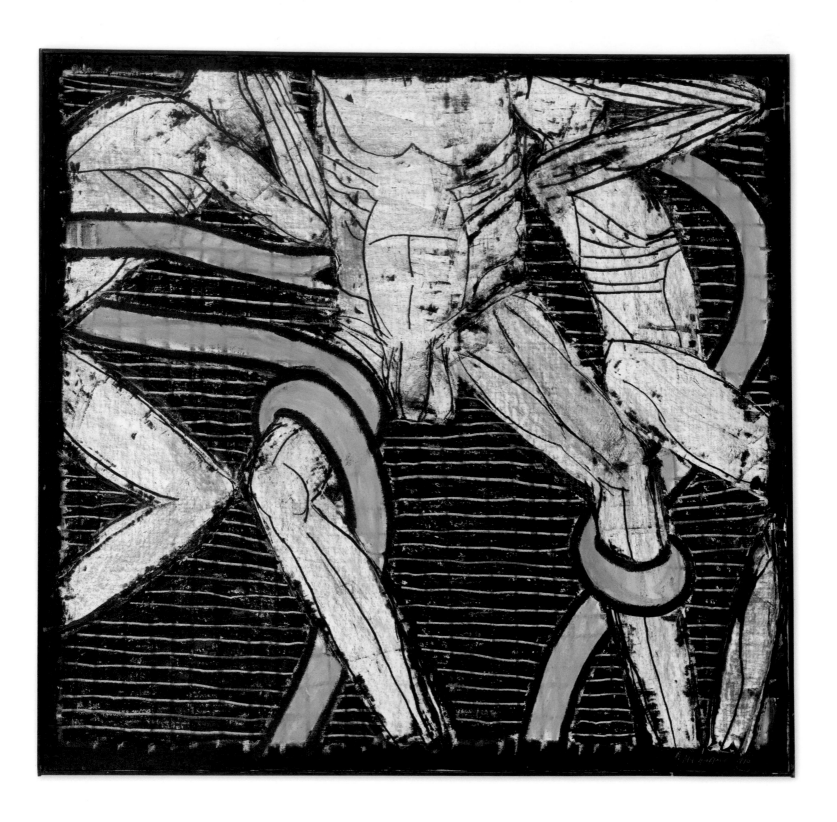

Laocoön Trio #1, 1990

The Lapiths and the Centaurs were once said to be brothers, descended from twin sons born to the god Apollo. The Lapiths were a civilized race of people renowned as horsemen and warriors, and sent many ships to join the Greek fleet during the Trojan War (according to the *Iliad*). The Centaurs were a different race, with the head, arms, and torso of a man and the body of a horse. They were wild and lascivious creatures, more primal in nature, though some were also known for great wisdom and skill, like the famed tutor of Achilles, Chiron.

The famous epic Battle of Lapiths and Centaurs broke out at the wedding of the King of the Lapiths to a famed horsewoman. The Centaurs were accused of drunken debauchery, beginning with molestation of the bride; the Lapiths, enraged, started a fracas and many Centaurs were killed before being run off. In the way of such things, this battle of brothers escalated and the ongoing hostilities between the races continued for many years.

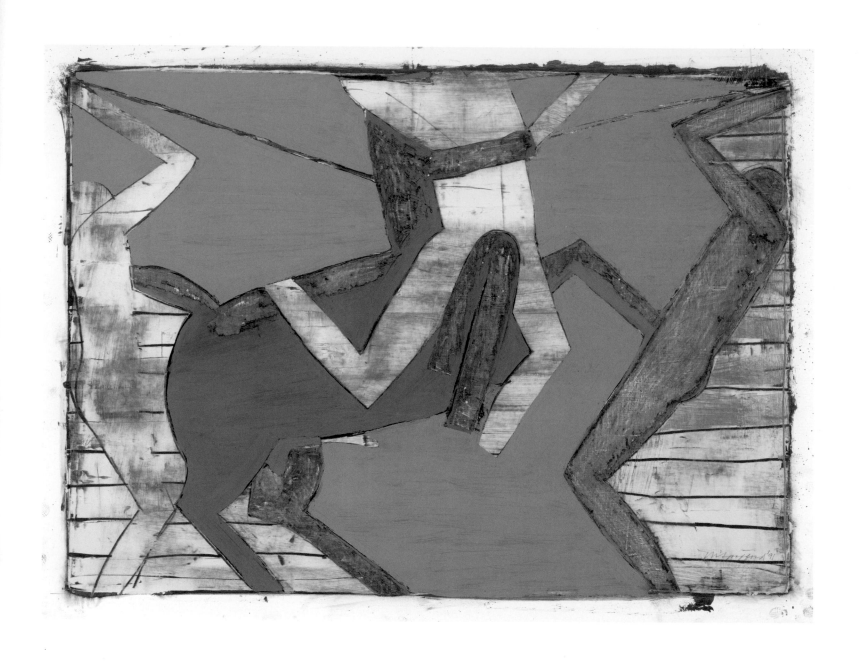

Lapiths and Centaurs, 1991

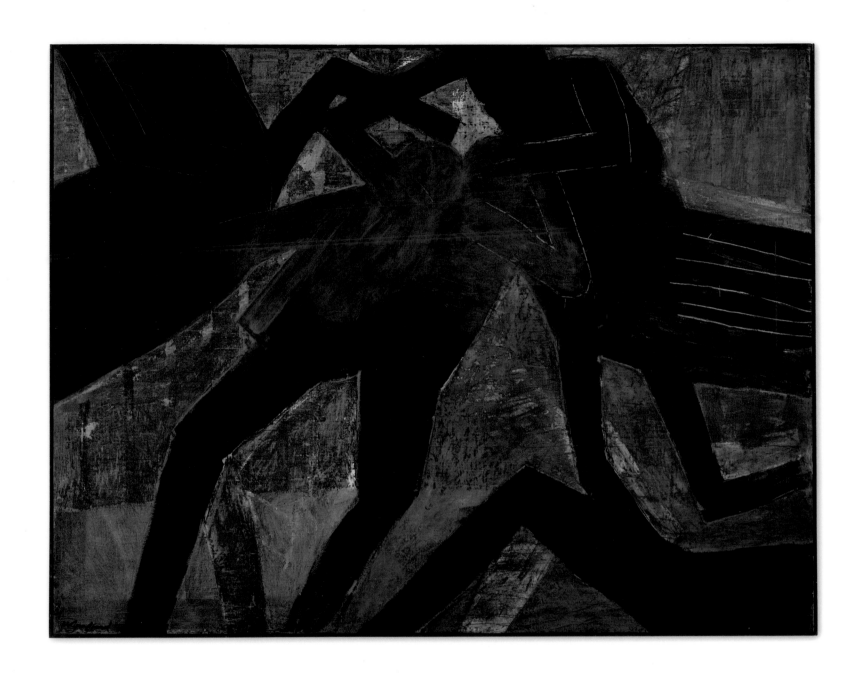

Lapiths and Centaurs, 1992

Leda and the Swan is a creation myth. Zeus fell in love with Leda, the wife of King Tyndareus of Sparta. The god encountered her one evening as she was bathing in a pool and assumed the form of a swan to seduce her. This meeting, as well as a later union between Leda and her husband, produced two eggs: one contained Helen (of Troy) and Pollux, both children of Zeus; while the other held Castor and Clytemnestra, offspring of Tyndareus.

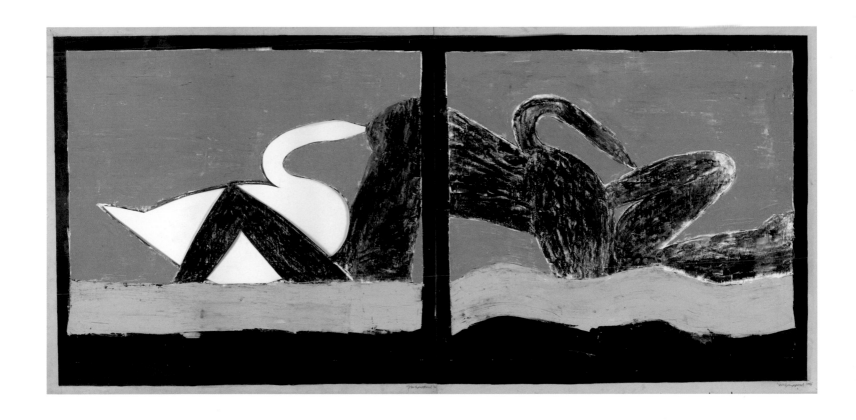

Leda and the Swan, 1996

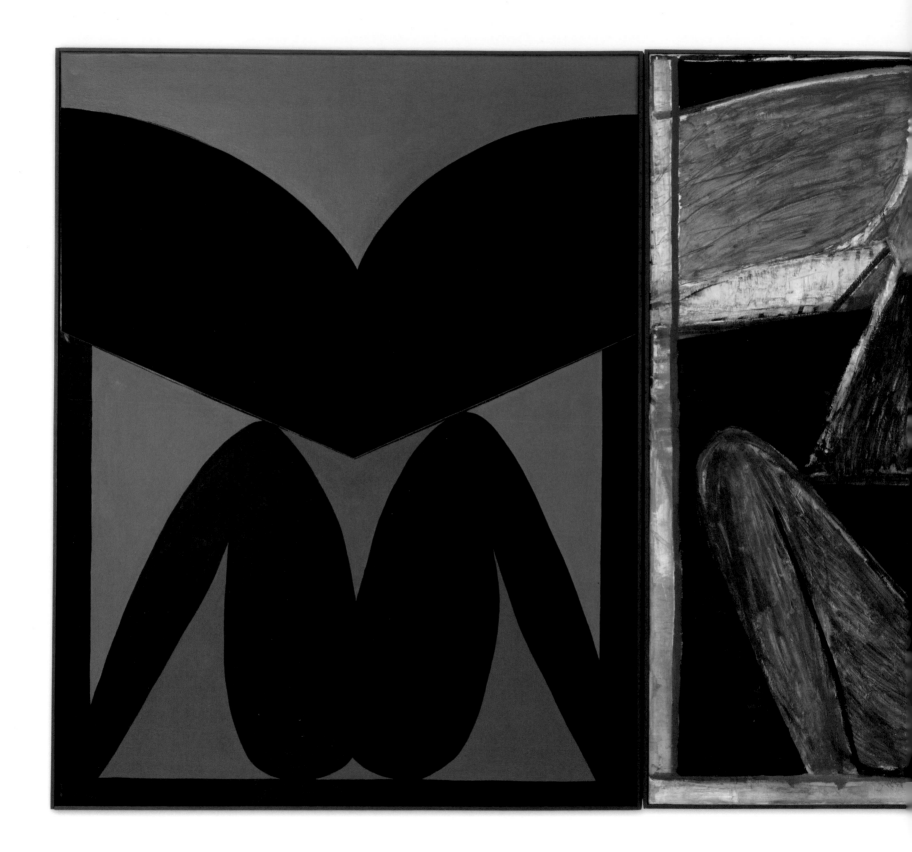

Leda Triptych, 1988

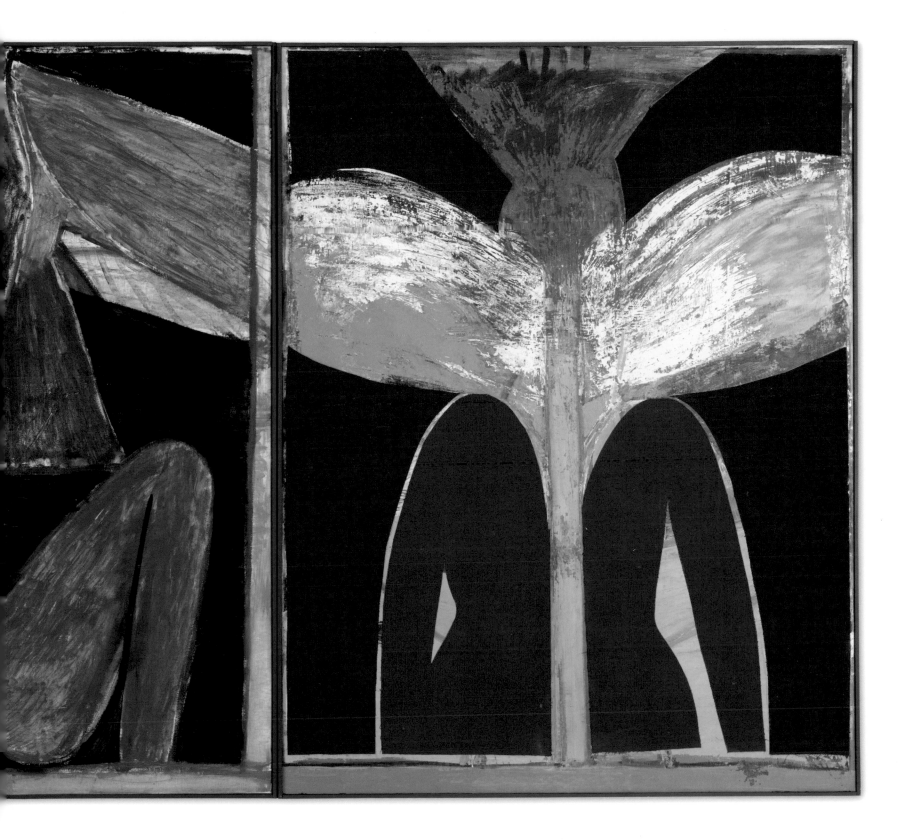

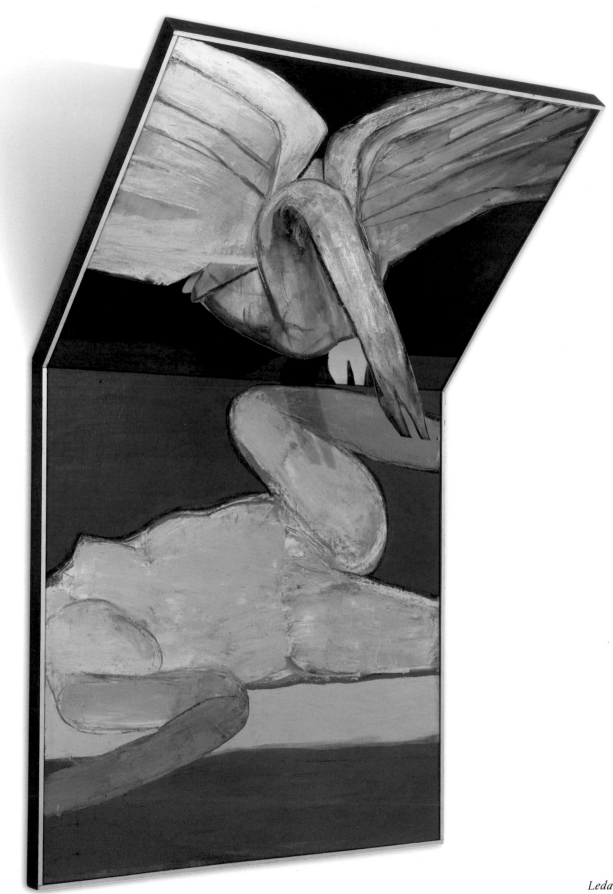

Leda & the Swan, 1968

Minos, powerful King of Crete, offended Poseidon who retaliated by causing his Queen to lust after a white bull. The offspring of that union was the Minotaur, a terrifying creature with the head of a bull and the body of a man. Minos was advised by an oracle to imprison the Minotaur in a vast labyrinth, designed by Daedalus from which there was no exit. When a son of Minos was killed in Athens, the Cretan king threatened war unless a sacrifice was made every nine years: seven of the most courageous youths and beautiful maidens were to be sent to Crete into the labyrinth to be devoured by the Minotaur. The legendary hero Theseus beloved of Athens, swore to slay the beast and was helped by Ariadne, daughter of King Minos. She gave him a ball of string which he tied to the doorpost at the entrance of the labyrinth unrolling the length as he went further inside. Theseus conquered the Minotaur after a great battle in the heart of the labyrinth and was able to retrace his steps to escape the maze.

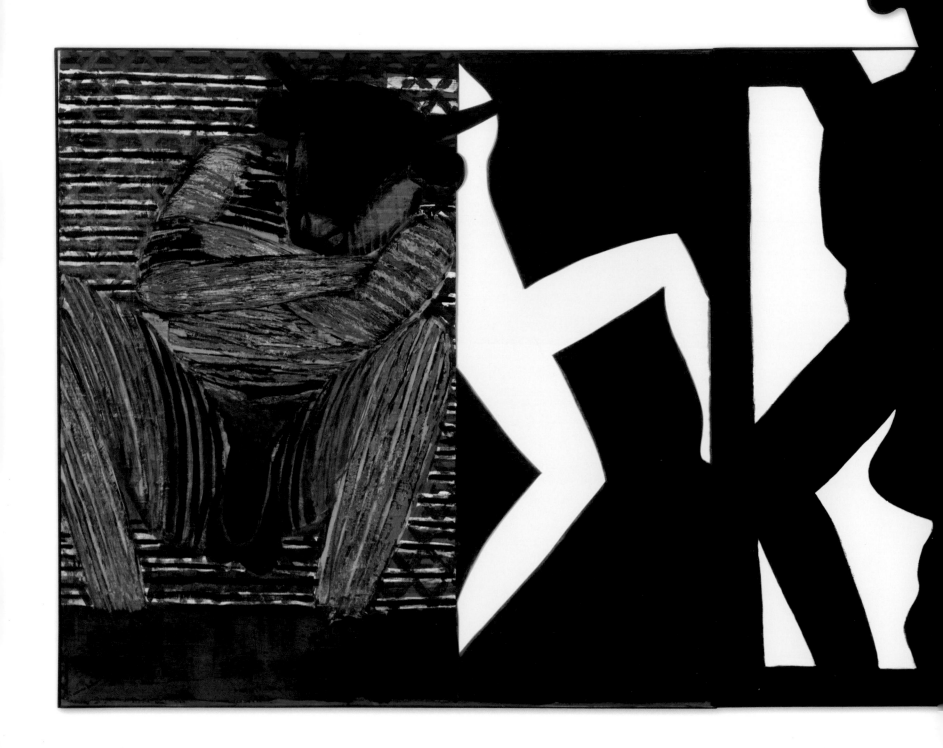

Minotaur I, 1988

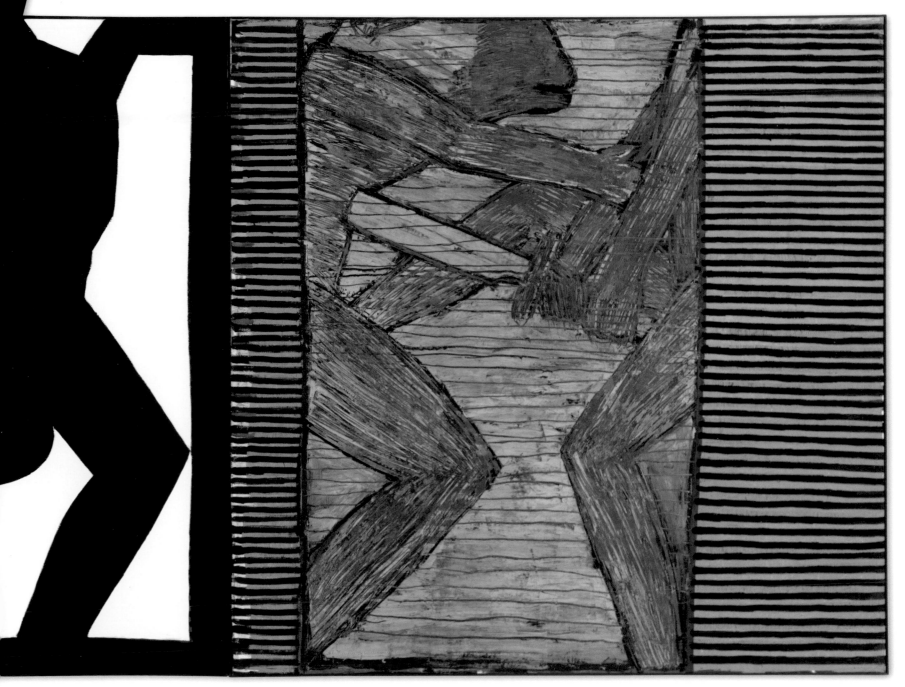

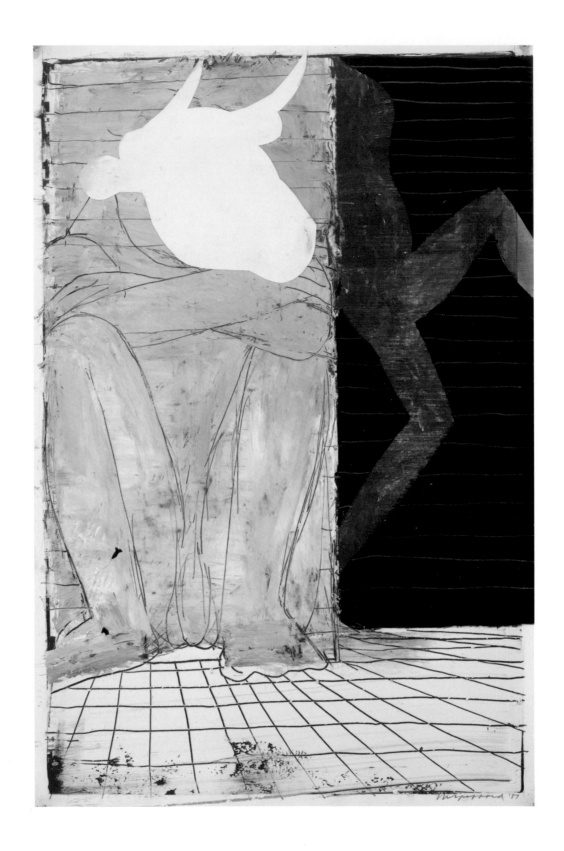

Minotaur, 1987

Perseus, one of the earliest legendary heroes of classical Greece, was also an authentic historical figure, a famed warrior and founder of the more ancient Mycenae. In legend he was half-mortal, son of the beautiful Danaë by Zeus, who visited her in a shower of gold. He shares many similarities and attributes with Hercules, Theseus, and other figures in heroic myth.

Perseus was the protagonist of many epic tales, one of which culminates in the slaying of the Gorgon Medusa. The king Polydectes, lusting after Danaë, sent the hero to slay this monstrous being with serpents for hair, a protruding tongue, and enormous teeth, so hideous that all who gazed upon her turned to stone. Guided by the goddess Athena, Perseus tricked both Hags and Nymphs out of their caches of magical weapons and was given a magical shield. Using it as a mirror, he was able to indirectly view and behead Medusa. Perseus returns home triumphant, uses the head to turn the treacherous king to stone, and presents it as gift to Athena, who honors him by placing it upon her shield.

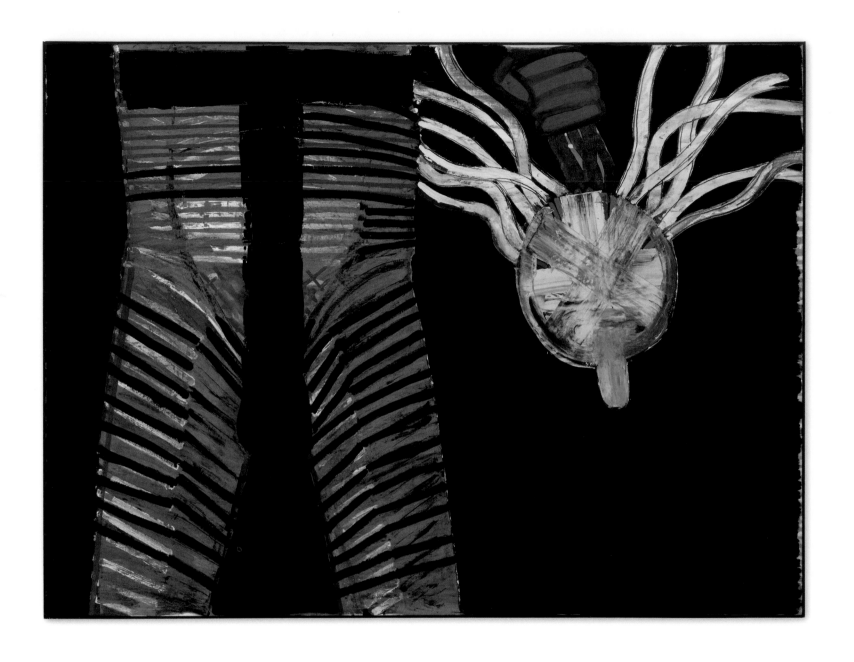

Perseus with Severed Head of Medusa, 1985

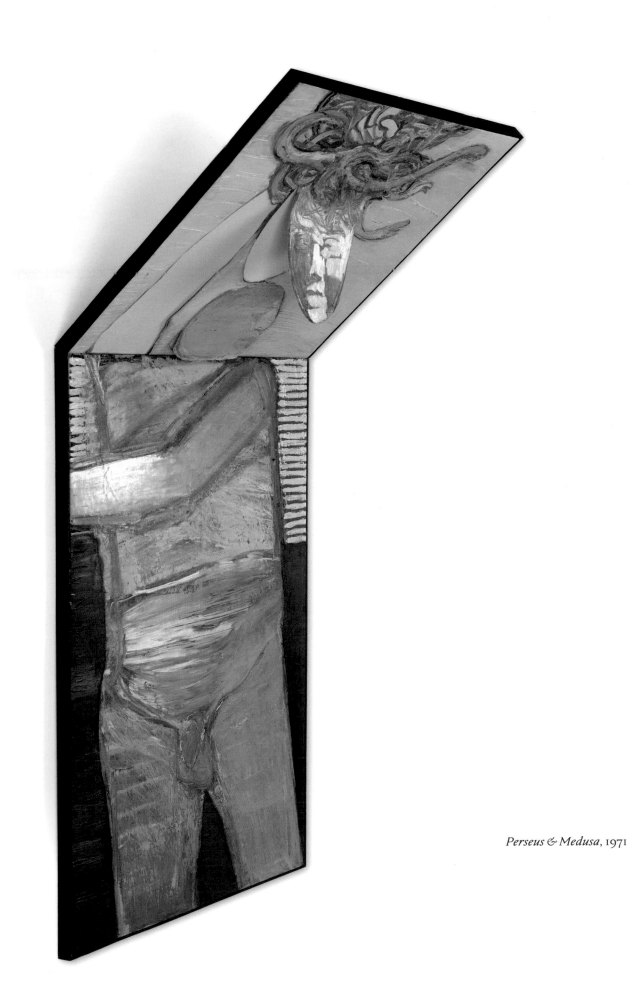

Perseus & Medusa, 1971

The *Iliad* is thought to be the oldest extant work of classical western literature. Followed by the *Odyssey*, it was part of an epic cycle of poems attributed to Homer and generally dated to around the eighth century BC. The *Iliad* takes the form of a saga of twenty-four 'books'; in the oral tradition, it was meant to be memorized and retold.

Set during the Trojan War, a brutal, ten-year siege of the city of Troy by a coalition of Greek states, the *Iliad* relates the events during the final weeks of battle. The glorious deeds of legendary warriors such as Hector, Paris, Ajax, and Odysseus are recounted, as is the quarrel between the fierce leader of the Greeks, King Agamemnon, and the immensely proud warrior Achilles. Many of the most powerful denizens of the divine realms took sides, and their attempts at intervention, based on the emotions and quarrels of their own, are determining factors throughout. Achilles plays the central role, and his personal rage and vanity propel the story: the malice or favor of the gods, the Greeks faltering in battle, the slayings of Patroclus and Hector, and the fall of Troy.

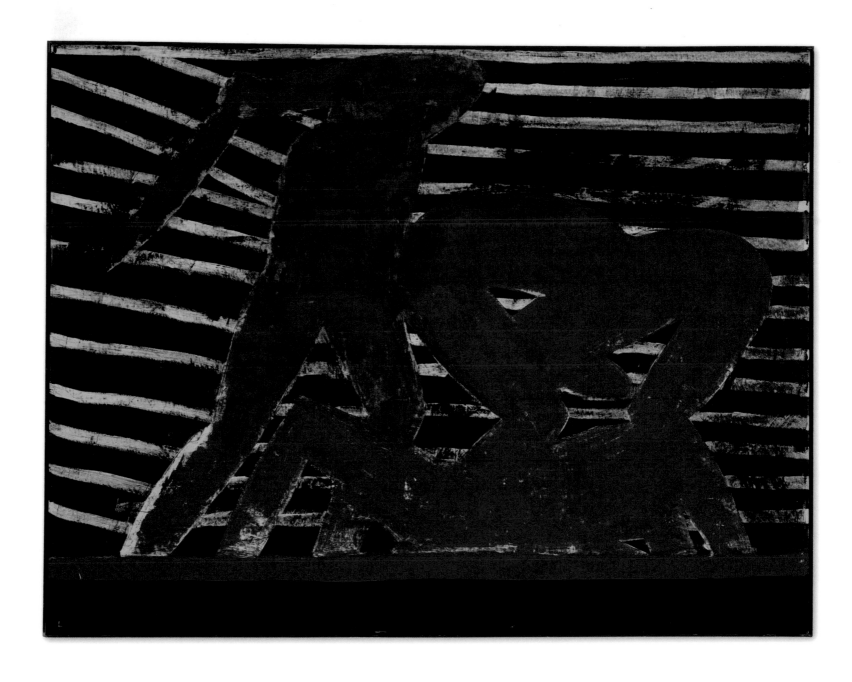

Achilles and Trojans, 2004

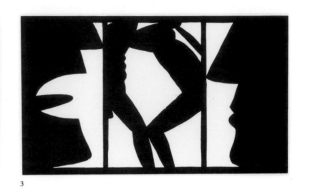

1

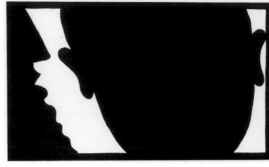

2

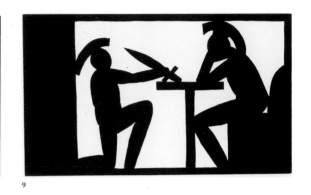

3

7

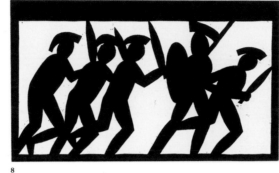

8

9

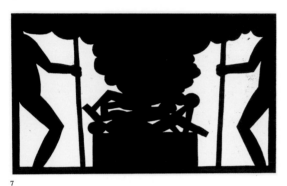

13

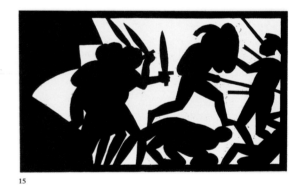

14

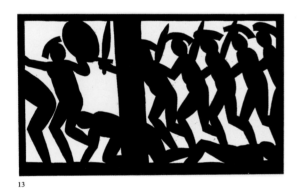

15

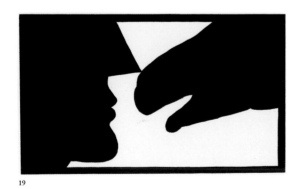

19

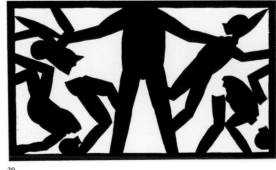

20

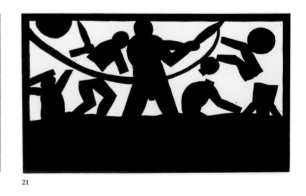

21

Iliad, 2004

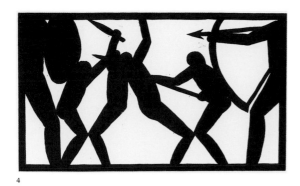

4

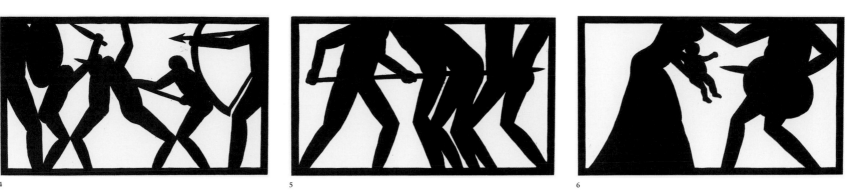

5

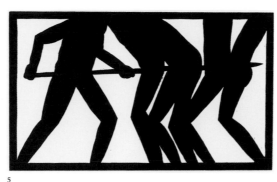

6

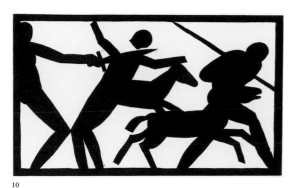

10

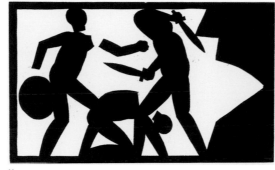

11

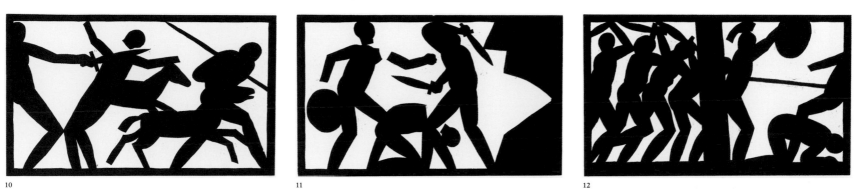

12

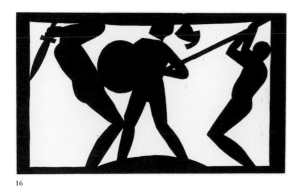

16

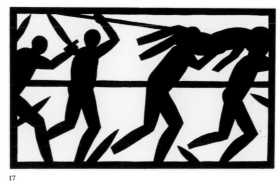

17

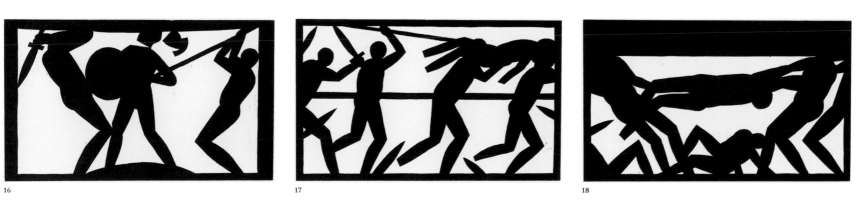

18

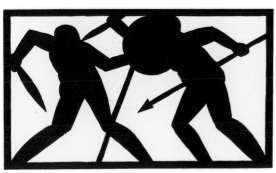

22

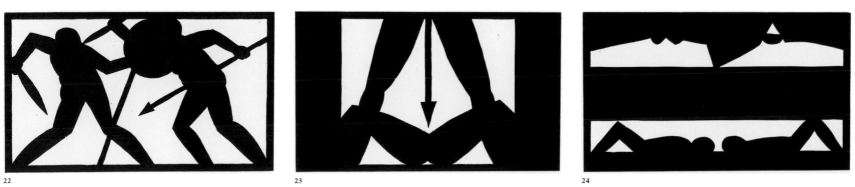

23

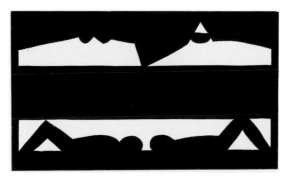

24

The *Odyssey*, sequel to the *Iliad*, is one of the oldest and most influential works of western literature, attributed to the Greek poet Homer. It is thought that this semi-historical saga may have included earlier epic songs and folktales common to the time (eighth century BC). It is the epitome of the voyage tale, in a highly accomplished non-linear style full of exciting episodes and many protagonists.

The *Odyssey* tells the story of the noble and cunning king Odysseus (known to the Romans as Ulysses) during his long return home after the fall of Troy. It is also a story of his wife, Penelope, and son, Telemachus, and of Zeus and Athena who, as ever, seek to influence the folly of humankind to their own ends. The first part of the saga tells of Telemachus's search for his father and Penelope's struggle with the many disreputable suitors who would replace the missing husband and king. Odysseus, meanwhile, has been taken captive by the nymph Calypso and held for seven years. The dramatic adventures which ensue are interspersed with many anecdotes and remembrances, often retold by the hero as tales within the tale itself. When he returns home at last, Odysseus and his son conspire to test the faithful Penelope and revenge themselves upon the abusive suitors. Slaying them and reuniting with his wife, he is favored by gods and regains his household.

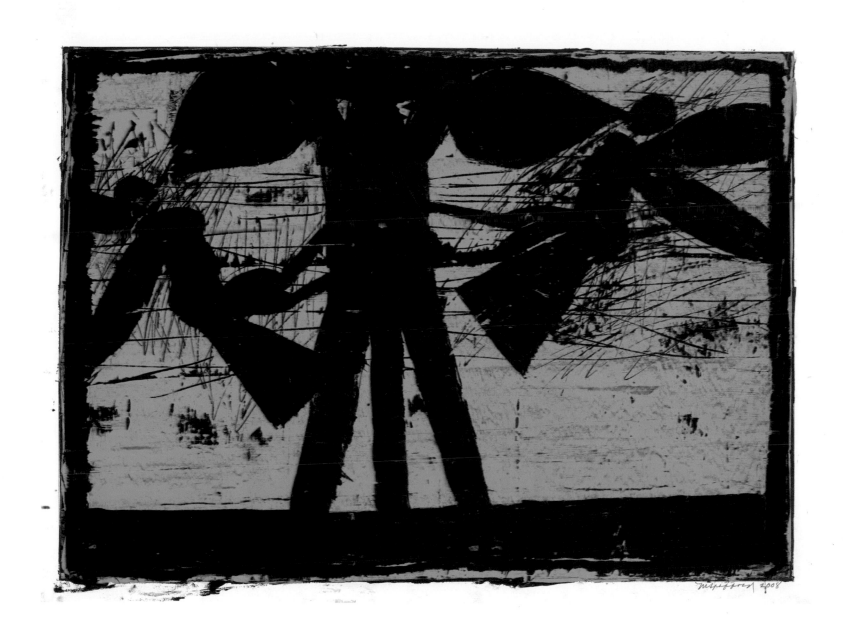

Odysseus Tempted by Sirens, 2008

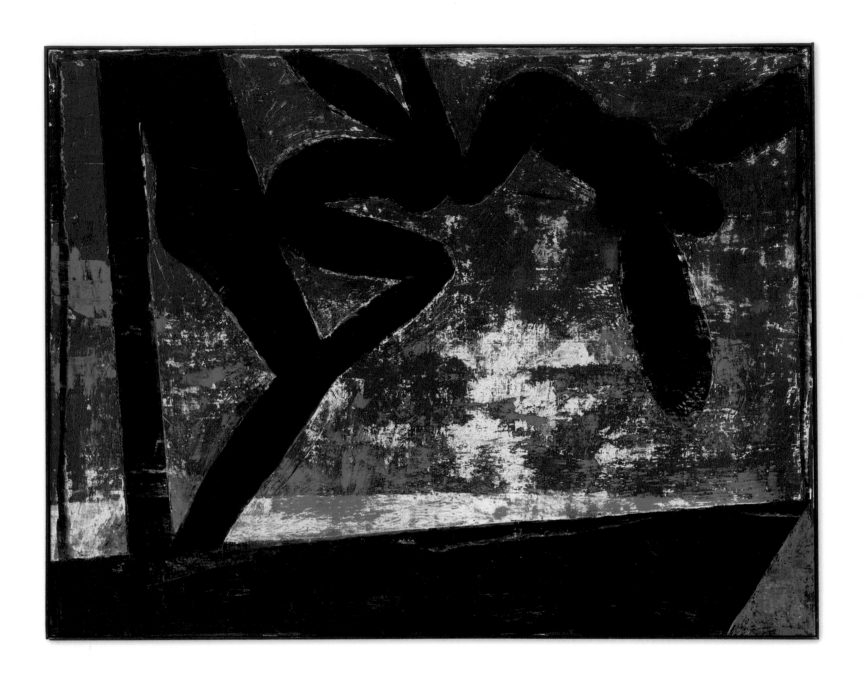

Temptation of Odysseus, 2008

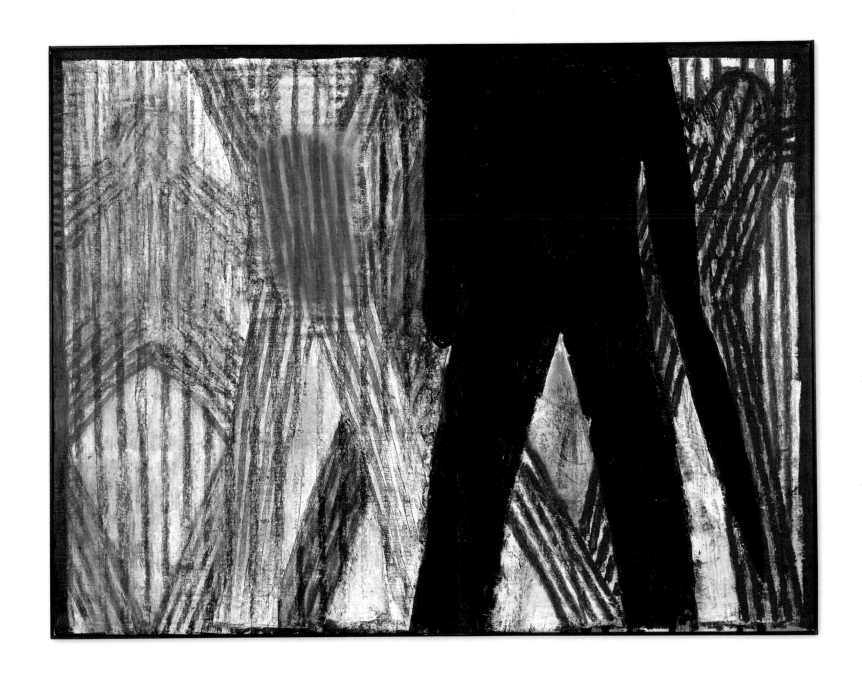

Odysseus in the Underworld, 2012

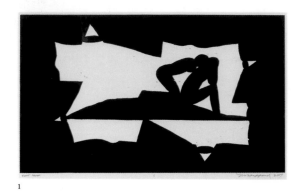

1

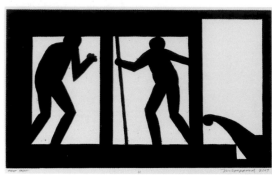

2

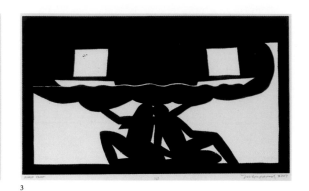

3

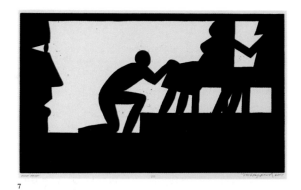

7

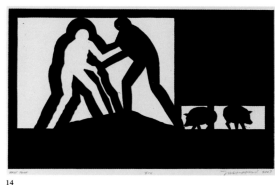

8

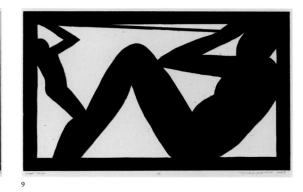

9

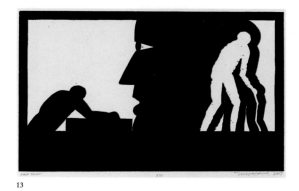

13

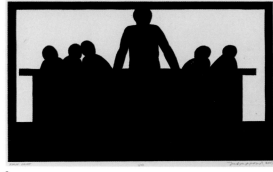

14

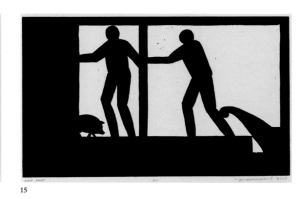

15

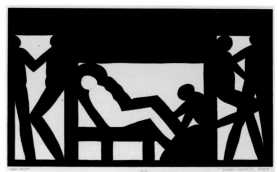

19

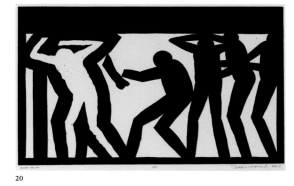

20

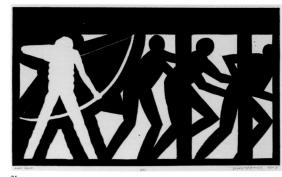

21

Odyssey, 2007

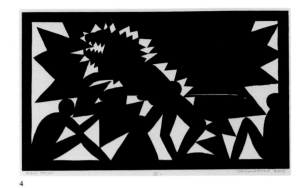

4

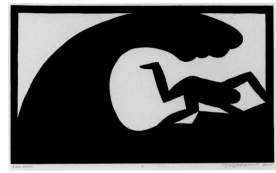

5

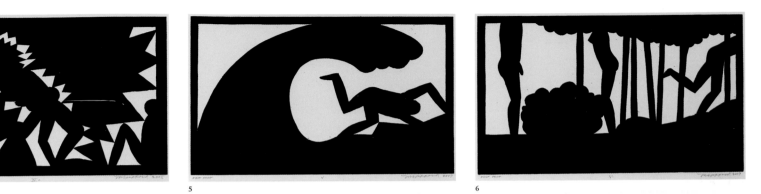

6

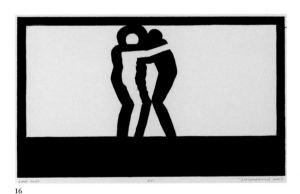

10

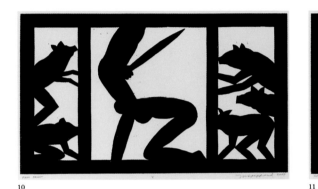

11

12

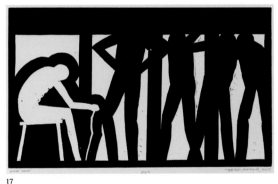

16

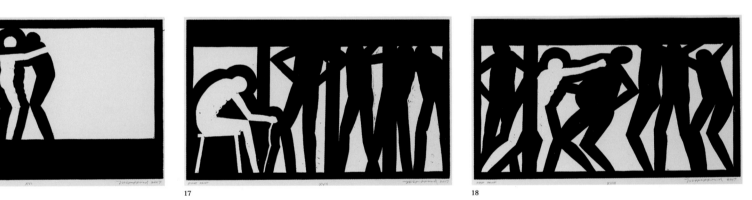

17

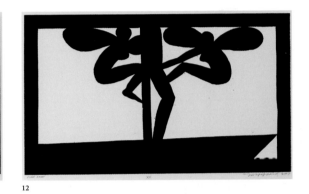

18

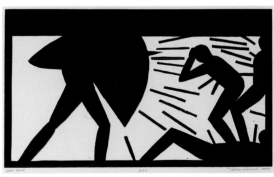

22

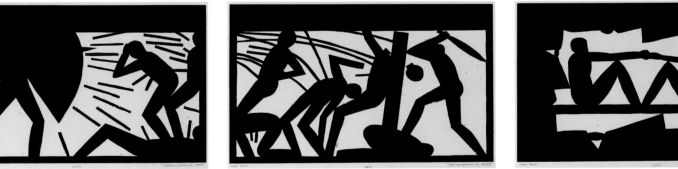

23

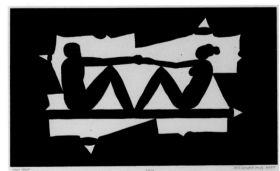

24

Wallace Stevens

I

Among twenty snowy mountains
The only moving thing
Was the eye of the blackbird.

II

I was of three minds,
Like a tree
In which there are three
 blackbirds.

III

The blackbird whirled in
 the Autumn winds.
It was a small part of the
 pantomime.

IV

A man and a woman
Are one.
A man and a woman
 and a blackbird
Are one.

V

I do not know which to prefer.
The Beauty of inflections
Or the beauty of innuendos,
The blackbird whistling
Or just after.

VI

Icicles filled the long window
With barbarous glass.
The shadow of the blackbird
Crossed it, to and fro.
The mood
Traced in the shadow
An indecipherable cause.

VII

O thin men of Haddam,
Why do you imagine golden birds?
Do you not see how the blackbird
Walks around the feet
Of the women about you?

VIII

I know noble accents
And lucid, inescapable rhythms;
But I know, too,
That the blackbird is involved
In what I know.

IX

When the blackbird flew
 out of sight
It marked the edge
Of one of many circles.

X

At the sight of blackbirds
flying in a green light,
Even the bawds of euphony
Would cry out sharply.

XI

He rode over Connecticut
In a glass coach.
Once a fear pierced him,
In that he mistook
The shadow of his equipage
For blackbirds.

XII

The river is moving
The blackbird must be flying.

XIII

It was evening all afternoon.
It was snowing
And it was going to snow.
The blackbird sat
In the cedar limbs.

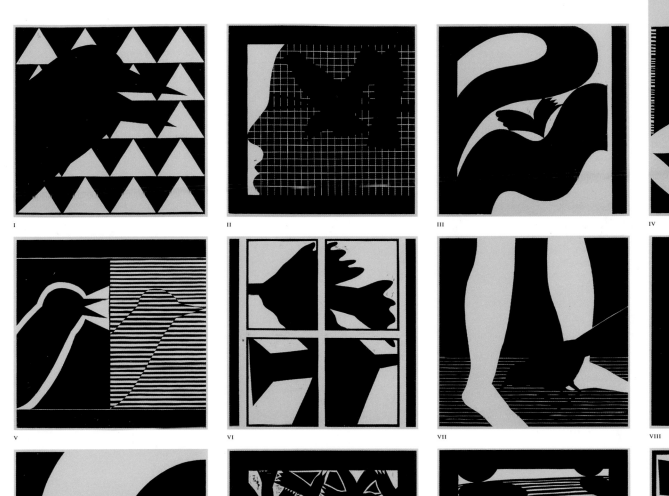

I II III IV

V VI VII VIII

IX X XI XII

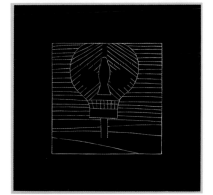

XIII

13 Ways of Looking at a Blackbird, 1986

Checklist

This catalogue presents work from a three-gallery exhibition in Seattle during April and May of 2018. At the invitation of the artist, Greg Kucera, John Braseth, and Sam Davidson, in collaboration with Zocalo Studios, curated a collection of major pieces by Spafford, with each gallery presenting distinct bodies of work grouped according to myth and medium.

DAVIDSON GALLERIES

Iliad, 2004
Oil-based woodblock print on paper
Edition of 10
24 sheets: 25½ × 19¾ inches (each)

13 Ways of Looking at a Blackbird, 1986
Oil-based woodblock prints on paper
Edition of 5
13 sheets: 25½ × 19¾ inches (each); image:
 15 × 15 inches (#1–3, 5); 15 × 18 inches (#4)

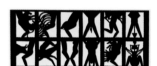

The 12 Labors of Hercules, 1998
Oil-based woodblock print on paper
Edition of 80
25½ × 19¾ inches (overall)

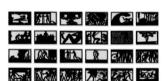

Odyssey, 2008
Oil-based woodblock prints on paper
Edition of 10
24 sheets: 25½ × 19¾ inches (each)

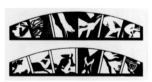

The Twelve Labors of Hercules, 1982
Oil-based woodblock print on paper
Edition of 10
2 sheets: 16 × 56½ inches (each)

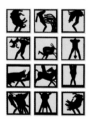

The 12 Labors of Hercules, 2001
Oil-based woodblock print on paper
Edition of 5
12 sheets: 25½ × 19¾ inches (each)

Achilles and Trojans, 2004
Oil on canvas
60¾ × 78¾ inches

Chimera #1, 1983
Painted and collaged woodcut
30 × 40 inches

Coatlicue V, 1980
Oil on canvas
75 × 87 inches

Icarus, 1968
Graphite and ink on paper,
mounted on plywood
75 × 93 inches (overall)

***The Battle of the Gods
and Giants***, 2002
Oil on canvas
78 × 144 inches

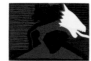

Chimera #3, 1983
Painted and collaged woodcut
30 × 40 inches

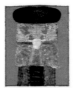

Coatlicue V, 1992
Oil and graphite on paper
72 × 60 inches

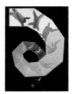

Icarus, 1971
Watercolor on paper
40 × 30 inches

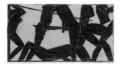

***The Battle of the Gods
and Giants I***, 2002
Oil on paper
21 × 36¾ inches

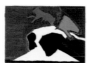

Chimera #6, 1983
Painted woodcut
30 × 40 inches

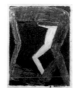

***Cronus Castrating
His Father***, 1995
Oil and graphite on paper
29 × 23⅛ inches

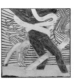

Laocoön—Sons & Serpents,
1989
Oil on canvas
81 × 81 inches

Bellerophon, 1968
Oil on canvas
Diptych; 91¾ × 136⅜ inches (overall);
 left: 68 × 87¾ (top) × 63 (bottom)
 inches; right: 68 × 62 (top) × 38
 (bottom) inches

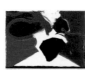

Chimera #7, 1983
Painted and collaged woodcut
30 × 40 inches

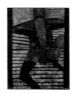

***Cronus Devouring
His Children #1***, 1995
Oil on canvas
78½ × 60½ inches

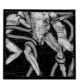

Laocoön Trio #1, 1990
Oil on canvas
50 × 48 inches

Bellerophon and Pegasus, 1970
Acrylic on paper with collage
36 × 43 inches

Death of Chimera, 1984
Oil on canvas
Triptych; 85½ × 262½ inches
 (overall); 85½ × 87½ inches
 (each panel)

Hercules with Bull, 2017
Mixed media on paper
42½ × 45 inches

Minotaur, 1987
Oil on paper
29 × 23⅛ inches

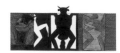

Minotaur I, 1988
Oil and acrylic on canvas and wood
Triptych; 100 × 216 inches (overall);
 left: *Waiting for Victim*, oil,
 78 × 78 inches; center: *Killing
 Victim*, acrylic, 100 × 78 inches;
 right: *Slain by Theseus*, oil,
 78 × 78 inches

Origin Myth 9, 1961
Oil on canvas
53½ × 71 inches

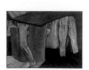

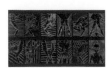

Perseus & Medusa, 1971
Oil on canvas
Diptych; 101½ × 44 inches (overall);
 top: 25½ × 44 inches; bottom:
 63½ × 44 inches

12 Labors of Hercules, 1995
Oil on canvas
75 × 125 inches

Origin Myth 15, 1964
Oil on canvas
66¾ × 83½ inches

*Perseus with Severed
Head of Medusa*, 1985
Oil on canvas
83 × 110 inches

WOODSIDE/BRASETH GALLERY

Birth of Athena #3, 2011
Oil on paper
40 × 30 inches

Europa and the Bull #6, 1986
Oil on paper
40 × 30 inches

Leda & the Swan, 1969
Oil on canvas, top panel with cutout
Diptych; 54¼ × 84 × 28 inches
 (overall); top: 51 × 38½ inches;
 bottom: 51 × 52 inches

Odysseus Tempted by Sirens,
2008
Oil on paper
39⅞ × 30 inches

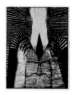

Birth of Athena, 2016
Oil on canvas
78½ × 60 inches

Lapiths and Centaurs, 1991
Oil on paper
30 × 40 inches

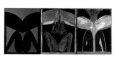

Leda Triptych, 1988
Oil on canvas
78 × 180 inches (overall);
 78 × 60 inches (each panel)

Odysseus in the Underworld,
2012
Oil on canvas
60¾ × 78¾ inches

Europa and the Bull #2, 1986
Oil and graphite on paper
 with cutout
30 × 40 inches

Lapiths and Centaurs, 1992
Oil on paper
60 × 78 inches

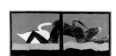

Leda and the Swan, 1996
Oil on paper
Diptych; 60 × 125⅝ inches (overall);
 60 × 62⅞ inches (each panel)

Temptation of Odysseus, 2008
Oil on canvas
60¾ × 78¾ inches

Selected Biography

BORN

Palm Springs, CA, 1935

EDUCATION AND TEACHING

1963–1994 Professor, University of Washington School of Art, Seattle, WA

1960 M.A. Harvard University, Cambridge, MA

1959 B.A. Pomona College, Claremont, CA

AWARDS AND GRANTS

2017 Lifetime Contribution to Northwest Art Award (with Elizabeth Sandvig), Museum of Northwest Art, La Conner, WA

2006 Mayor's Art Award, Family of Northwest Artists: Spike Mafford, Elizabeth Sandvig, Michael C. Spafford, Seattle, WA

2005/2006 Award for Visual Artist, Flintridge Foundation, Pasadena, CA

2005 Artist-in-Residence, Dartmouth College, Hanover, NH

1999 Lifetime Achievement in the Arts Award, Corporate Council for the Arts, Seattle, WA

1996 Neddy Artist Award, The Behnke Foundation, Seattle, WA

1987 Centrum Print Commission, Fort Worden, WA

1983 Art Award, American Academy and Institute of Arts and Letters, New York, NY

1979 King County Arts Commission's Honors Award, Seattle, WA

1967–1969 Rome Prize Fellowship, American Academy, Rome, Italy

1965–1966 Louis Comfort Tiffany Foundation Grant, New York, NY

SOLO EXHIBITIONS

2013 *Hercules and Other Greek Legends*, Study and Print Study Center, Hallie Ford Museum of Art, Willamette University, Salem, OR

2010 *Prints and Monoprints*, Francine Seders Gallery, Seattle, WA

2009 *Images from The Odyssey*, Francine Seders Gallery, Seattle, WA

2006 *Paintings & Works on Paper*, Laura Russo Gallery, Portland, OR

2005 *Of Gods and Giants*, Jaffe-Friede & Strauss Galleries, Dartmouth College, Hanover, NH

2005 *The Iliad*, Francine Seders Gallery, Seattle, WA

2001 *Prints*, Francine Seders Gallery, Seattle, WA

2000 *Myths and Metaphors*, Hockaday Museum of Art, Kalispell, MT

2000 *Prints,* Francine Seders Gallery, Seattle, WA

1999 *Myths and Metaphors*, The Art Gym, Marylhurst University, Marylhurst, OR

1997 *Prints*, Francine Seders Gallery, Seattle, WA

1995 *Prints,* Francine Seders Gallery, Seattle, WA

1994 *Woodcuts*, Francine Seders Gallery, Seattle, WA

1994 *A Mythological Narrative*, Cheney Cowles Museum, Spokane, WA

1993 *Woodcuts*, Whatcom Museum of History and Art, Bellingham, WA

1993 *Prints*, Francine Seders Gallery, Seattle, WA

1992 Blackfish Gallery, Portland, OR

1992 *Visions of Myth*, Sheehan Gallery, Whitman College, Walla Walla, WA,

1992 *Origins*, Bellevue Art Museum, Bellevue, WA

1991 *New Work*, Francine Seders Gallery, Seattle, WA

1991 *Origins*, Bellevue Arts Museum, Bellevue, WA

1991 *Prints*, Francine Seders Gallery, Seattle, WA

1990 Index Gallery, Clark College, Vancouver, WA

1987 *The Mythic Themes of Michael Spafford*, Whatcom Museum of History and Art Gallery, Bellingham, WA

1986 *Documents Northwest: Michael Spafford*, Seattle Art Museum, Seattle, WA

1986 *Recent Woodcuts*, Baskin Gallery, Tacoma Art Museum, Tacoma, WA

1986 *Prints*, Francine Seders Gallery, Seattle, WA

1985 *Bumberbienniale – Art Since Century 21*, Bumbershoot Festival, Seattle Center, Seattle, WA

1984 *Works from the Chimera Series*, Vollum College Center Gallery, Reed College, Portland, OR

1983 *Prints*, Francine Seders Gallery, Seattle, WA

1982 *Wentz Gallery*, Pacific Northwest College of Art, Portland, OR

1982 Seattle Art Museum, Seattle, WA

1982 *Woodcuts*, Wentz Gallery, Pacific Northwest College of Art, Portland, OR

1980 *Prints*, Francine Seders Gallery, Seattle, WA

1977 *Prints*, Francine Seders Gallery, Seattle, WA

1976 *Prints*, Francine Seders Gallery, Seattle WA

1975 Utah Museum of Fine Arts, Salt Lake City, UT

1975 Tacoma Art Museum, Tacoma, WA

1973 Kittredge Gallery, University of Puget Sound, Tacoma, WA

1972 *Prints*, Francine Seders Gallery, Seattle, WA

1969 *Prints*, Francine Seders' Otto Seligman Gallery, Seattle, WA

1967 Francine Seders' Otto Seligman Gallery, Seattle, WA

1966 Westside Federal Savings and Loan, Seattle and Burien, WA

1966 Tacoma Art Museum, Tacoma, WA

1965 Otto Seligman Gallery, Seattle, WA

1963 Galcrias C.D.I. Mexico City, Mexico

1962 Mexican-North American Cultural Institute, Galerias Norte y Sur, Mexico City, Mexico

SELECTED GROUP EXHIBITIONS

2017 CoCA Legacy: Retrospective Exhibition from 36 years, Center on Contemporary Art, Seattle, WA

2016 *What's New at TAM? Recent Acquisitions*, Tacoma Art Museum, Tacoma, WA

2013 *Jacob Lawrence and Michael Spafford*, Francine Seders Gallery, Seattle, WA

2011 *A Family Show*, Francine Seders Gallery, Seattle, WA

2011 *Seattle as Collector*, Seattle Office of Arts & Cultural Affairs Turns 40, Seattle Art Museum, Seattle, WA

2010 *Honoring 15 Years of Neddy Artist Fellows*, Tacoma Art Museum, Tacoma, WA

2010 *A Continuing Cultural Legacy: Selections from the Safeco Insurance Collection Donation to the WA Art Consortium*, Wright Exhibition Space, Seattle, WA

2008 *Century 21: Dealer's Choice*, Wright Exhibition Space, Seattle, WA

2008 *Seattle Public Utilities Northwest Masters Portable Works*, Mayor's Office of Arts & Cultural Affairs, Seattle Municipal Tower Gallery, Seattle, WA

2006 *8th Northwest Biennial*, Tacoma Art Museum, Tacoma, WA

2005 *Private Art by Public Artists*, Seattle Art Museum, Seattle, WA

2005 *A Decade of Excellence: Celebrating the Neddy Artist Fellowship*, Tacoma Art Museum, Tacoma, WA

2002–2004 *Les Fables de La Fontaine*, Centre pour L'Art et la Culture, Aix-en-Provence, France

Temple University, Rome, Italy

Jacob Lawrence Gallery, University of Washington, Seattle, WA

The Meyerhoff Gallery, The Maryland Institute College of Art, Baltimore, MD

2002 *Shared Labors: Spike Mafford and Michael Spafford*, Francine Seders Gallery, Seattle, WA

2002 *Francis Celentano, Robert Jones, Michael Spafford: Three Eminent Northwest Artists*, Laura Russo Gallery, Portland, OR

2001 *Northwest Views: Selections from the SAFECO Collection*, Frye Art Museum, Seattle, WA

2000 *Artists Making Prints*, Jacob Lawrence Gallery, University of Washington, Seattle, WA

1998 *The Yang of It: R. Allen Jensen – New Work, More Work, Michael Spafford – The Twelve Labors of Hercules*, Museum of Northwest Art, La Conner, WA

1997 *Curatorial Choice: A Northwest Survey*, Sherman Gallery, Holter Museum of Art, Helena, MT

1997 *Neddy Artist Fellowship Exhibit*, Seafirst Gallery, Seattle, WA; Port Angeles, Fine Arts Center, Port Angeles, WA

1996 *The Neddy Inaugural Art Exhibit, Gallery of Art*, Washington State Convention and Trade Center, Seattle, WA

1995 *Purchase Exhibition, American Academy and Institute of Arts and Letters*, New York, NY

1993–1994 *The Art of Microsoft*, Henry Art Gallery, University of Washington, Seattle, WA

1991 *Purchase Exhibition*, American Academy and Institute of Arts and Letters, New York, NY

1990 *Views and Visions in the Pacific Northwest*, Seattle Art Museum, Seattle, WA

1988 *Pomona College Alumni Artists: A Centennial Exhibition*, Claremont, CA

1987 *Focus: Seattle*, San Jose Museum of Art, San Jose, CA

1986 *Studies for Murals and Sculpture*, Francine Seders Gallery, Seattle, WA

1986 *Centrum Northwest Artist Print Project*, Davidson Galleries, Seattle, WA,

1986 *Poncho Preview*, Seattle Art Museum, Poncho Gallery, Seattle, WA

1986 *Pacific Northwest Arts Council Annual Meeting and Benefit Exhibition*, Seattle Art Museum, Seattle, WA

1986 *Northwest Image: Lucinda Parker and Michael Spafford*, Washington State University, Pullman, WA

1984 *Size*, Bumbershoot Festival, curated by Matthew Kangas, Seattle Center, Seattle, WA

1983 *Bumberbienniale - Art Since Century 21*, Bumbershoot Festival, Seattle Center, Seattle, WA

1982 *Pacific Northwest Drawing Invitational*, organized by Eastern Washington University, Cheney, WA, traveled Kent State University, Kent, OH; University of Wisconsin-Stout, Menomonie, WI; Lawrence University, Appleton, WI; University of Maine, Portland, ME; Atlanta College of Art, Atlanta, GA; and University of Tennessee, Knoxville, TN

1982 *Contemporary WA State Artists*, Cranberry Gallery, Plymouth, MA

1981 *Portopia '81*, Port Kobe, Japan

1980 *Northwest Artists: A Review*, Seattle Art Museum, Seattle, WA

1977 *Faculty Exhibition*, Henry Art Gallery, University of Washington, Seattle, WA

1977 *Northwest '77*, Seattle Art Museum, Seattle, WA

1977 *37th Annual Exhibition of Watercolor Paintings*, Bellevue Art Museum, Bellevue, WA

1977 *Figures in Motion: Narrative works by Joan Brown, Jacob Lawrence and Michael Spafford*, Wilcox Gallery, Swarthmore College, Swarthmore, PA

1977 *Masters of the Northwest*, Seattle Art Museum, Seattle, WA

1976 *First National Drawing Competition*, Bellevue Arts Museum, Bellevue, WA

1974 *Art of the Pacific Northwest from the 1930s to the Present*, Smithsonian Institution, Washington, DC, Traveling Exhibition

1974 *Annual Exhibition of Northwest Artists*, Seattle Art Museum, Seattle, WA

1971 *73rd Western Annual*, Denver Art Museum, Denver, Colorado

1970 *The Drawing Society National Exhibition*, American Federation of Arts, Traveling Exhibition

1969 *Annual Exhibition*, American Academy in Rome, Italy

1968 *Group Exhibition*, Nordness Galleries, New York, NY

1968 *Annual Exhibition*, American Academy in Rome, Italy

1967 *Governor's Invitational*, State Capitol Museum, Olympia, WA

1967 *Annual Watercolor Exhibition*, Seattle Art Museum, Seattle, WA

1967 *Faculty Exhibition*, Henry Art Gallery, University of Washington, Seattle, WA

1966 *Governor's Invitational*, State Capitol Museum, Olympia, WA

1966 *Art Across America*, San Francisco Museum of Art, San Francisco, CA

1966 *Mercyhurst Annual Exhibition*, Mercyhurst College, Erie, PA

1966 *Group Exhibition*, Zora's Gallery, Los Angeles, CA

1965 *Art Across America: National Selection*, Knoedler Galleries, New York, NY, Traveling Exhibition

1965 *Group Exhibitions*, Galeria Turok-Wasserman, Mexico City, Mexico

1964 *Group Exhibition*, Jason Gallery, New York, NY

1963 *Faculty Exhibition*, Henry Art Gallery, University of Washington, Seattle, WA

1962 *4th Annual San Miguel Allende Exhibition*, San Miguel Allende, Mexico

1961 *Group Exhibition*, Galeria de Arte Mexicano, Mexico City, Mexico

SELECTED PUBLIC AND CORPORATE COLLECTIONS

Corr Cronin, Seattle, WA

Cheney Cowles Museum, Spokane, WA

Davis, Wright and Tremaine, Seattle, WA

Hallie Ford Museum of Art, Willamette University, Salem, OR

Hood Museum of Art, Dartmouth College, Hanover, NH

Jundt Art Museum, Gonzaga University, Spokane, WA

Junior League of Seattle, WA

King County Arts Commission, Seattle, WA

Kirkland Art Association, Kirkland, WA

Lower Columbia College, Longview, WA

Mexican-North American Cultural Institute, Mexico, D.F.

Microsoft Corporation, Redmond, WA

Mundt, MacGregor, Falconer, Zulauf, and Hall, Seattle, WA

Museum of Modern Art, Dallas, TX

Museum of Art, Washington State University, Pullman, WA

Odegaard Undergraduate Library, University of Washington, Seattle, WA

PACCAR Collection, Seattle, WA

Pacific National Bank of Washington, Tacoma, WA

Pacific Northwest Bell, Seattle, WA

Pacific Recreational Association, Bellevue, WA

The Polyclinic, Seattle, WA

Portable Works Collection, City of Seattle, Seattle, WA

Portland Art Museum, Portland, OR

Swedish Hospital, Seattle, WA

Tacoma Art Museum, Tacoma, WA

University of Washington, Seattle, WA

US West New Vector Group, Bellevue, WA

Verizon Wireless, Bellevue, WA

Washington Art Consortium, Bellingham, WA

Washington State's Art in Public Places Program, Vocational/Art Facility, Shoreline College, Seattle, WA

Washington State Collection, Olympia, WA

Washington State Convention Center, Seattle, WA

SITE-SPECIFIC COMMISSIONS

1984 *Thirteen Ways of Looking at a Blackbird*, Seattle Opera House (now McCaw Hall), Seattle, WA

1981 *Twelve Labors of Hercules*, House of Representatives Chamber, Olympia, WA (relocated in 2003 to Centralia College's Corbet Theater)

1979 *Tumbling Figure – 5 Stages*, Kingdome, Seattle, WA (relocated in 2005 to King County Administration Parking Facility)

MICHAEL C. SPAFFORD

TOP
↑